Wood Sculpture

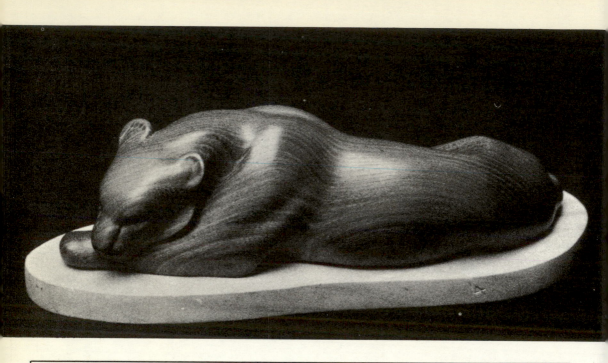

Every man has his gift, and the tools go to him that can use them
Charles Kingsley

Wood Sculpture

Ronald Cartmell

F.T.C. Grad. I.Ex.E.

1st class award in technological subjects,
City & Guilds of London Institute

Crafts Master, Carlisle Education Authority

with diagrams by the author

**TAPLINGER
PUBLISHING COMPANY**
New York

ALLMAN & SON
London

A
1800

First published in Great Britain 1970 by
Allman & Son Limited, 17–19 Foley St,
London W1A 1DR

First published in the United States in 1970
by Taplinger Publishing Co., Inc. New York, N.Y.

Reprinted 1971

British ISBN 0 204 68714 4
American ISBN 0 8008 8470 1

Library of Congress Catalog Number
79–109010

Photoset by BAS Printers Limited,
Wallop, Hampshire
Printed in Great Britain by
Ebenezer Baylis & Son Limited,
The Trinity Press, London, and Worcester

Contents

Plates

Acknowledgments

Thanks and acknowledgments are due and are gratefully given to the following: Mr. Henry Moore for permission to include photographs of some of his work: Mr. Gino Masero for his invaluable help and suggestions: Miss Nancy Catford for permitting me to reproduce photographs of her work: Mr. Michael Smith: Mr. F. W. Miles: Miss Barbara Linley-Adams: Mr. Robert W. Forsyth: Mr. Walter Tiffany, of Pinewood Studios: Miss A. V. Gardiner (Head of Art Department) Avery Hill College of Education: Mr. W. J. D. Clarke: Mr. David M. Short: Mr. B. A. L. Cranstone, Assistant Keeper, Department of Ethnography, The British Museum: Mr. T. W. I. Hodgkinson, Keeper, Department of Architecture and Sculpture, Victoria and Albert Museum: Miss Judy Mitchell.

Thanks are also due to Messrs. G. Smirthwaite and Sons: Stanley Works (Great Britain) Limited: Aaron Hildick Limited: Timber Development Association Limited: Council of Industrial Design: The Crafts Centre of Great Britain (President H.R.H. The Duke of Edinburgh K.G.).

Finally I must express my gratitude to those involved in seeing the book through the press, and especially to Mrs. E. J. Bryant for her helpful and encouraging suggestions.

R.C.

Fig 1 Longitudinal Section of a Log

Pith. This is the first stage of the growth of the tree. Its diameter is about that of a pencil. Soft and porous, it is useless as timber.

Medullary Rays. Appear as lines radiating from the centre. May be seen clearly in some woods, whilst in others may not be seen at all.

Annual Rings. These are the layers that are formed each year. The first four or five years of growth are hardly visible, but after that the rings become much easier to detect. Thus we can determine (within a few years) the age of the tree. The study of this growth structure is a science called Dendrochronology.

Sapwood. This is the new growth of the tree and is lighter in colour, and (due to the sap), is wetter and softer than the heartwood.

Heartwood. The mature part of the tree yielding the best timber.

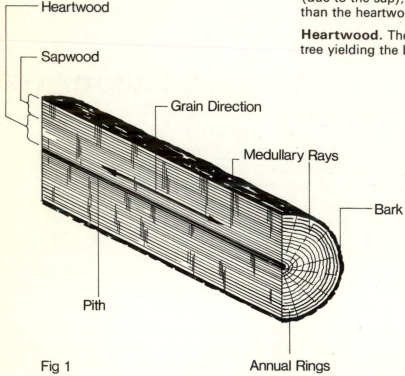

Fig 1

Wood Sculpture

Sculpture is the art of carving or modelling in the round or in relief, the materials usually employed being marble, stone, clay, metal or wood.

We shall use wood as the medium for our sculptures, so first of all I shall deal with the material.

Most designed shapes are to some degree influenced by the material used, and different materials have characteristic shapes of their own, expressing the nature of the particular medium.

Wood, like other natural materials, has its own character and the sculptor should know something about the material he is working with.

Wood, instead of being a relatively solid material like metal or stone, is composed of many tubular fibre units, or cells, all fixed together. And it is this cellular structure that produces the characteristic 'grain'* on a piece of wood when it is cut from a log (Fig 1). This grain has much more strength across its width than along it; we can prove, as in Fig 2A and B, how comparatively easy it is to split wood along the grain, but most difficult to fracture it across.

It will also be found to cut easily along the grain with a chisel or a plane, but will splinter at the edges when cut across (2C and D).

In some woods the run of the grain can be very troublesome, even to an experienced carver. So, to the beginner — I would strongly advise you to select fairly straight grained woods that are soft and easy to work (see Table of Suitable Timbers) at least until you've had a bit more practice at carving.

Wood, as well as having this characteristic grain, is hygroscopic, that is to say it will give off or absorb moisture according to the atmospheric conditions. For example, the average moisture content of wooden furniture in the home will be around 12 per cent. It will probably vary between 10 and 14 per cent according to the time of year and the type of heating used in the home.

*'Grain' a term used to define the figure that is produced by the annual rings; this may be coarse, fine, or straight-grained. The texture of a piece of wood may also be referred to as being open or close-grained.

These fluctuations are inevitable, but provided that the piece of timber to be used for a carving has been seasoned to a moisture content approximating to the average conditions of location, then the seasonal variations will prove to be no trouble.

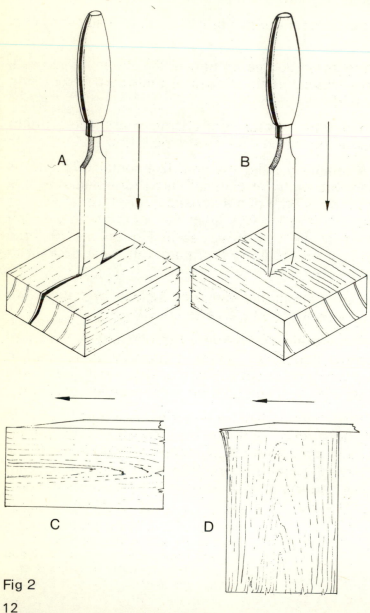

Fig 2

Moisture Content

Calculation of Moisture Content

Saw a test piece as shown in Fig 3 and weigh this sample accurately. This is the weight of the wood plus any moisture which is present. This is known as the 'wet weight'. Then, take the sample and dry it in an oven for about half an hour or so; re-weigh the sample, and make a note of its weight. ·Continue to dry the sample and re-weigh about every half-hour until eventually the weight remains constant. When this happens the weight is again noted and called the 'dry weight'.

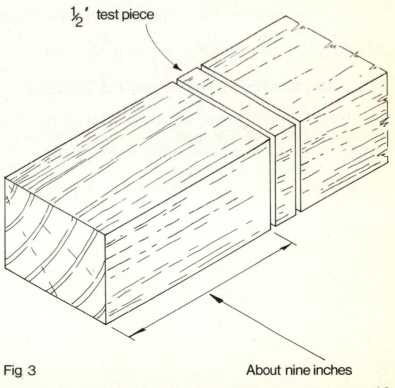

½' test piece

Fig 3

About nine inches

The following formula is now applied to find the proportion of water to dry wood in the original piece of wood.

$$\text{Moisture Content} :- \frac{\text{Wet Weight} - \text{Dry Weight}}{\text{Dry Weight}} \times 100\%$$

Example

Wet Weight = 4·5 ozs
Dry Weight = 3·0 ozs

$$\text{Moisture Content} = \frac{4·5 - 3·0}{3·0} \times 100\%$$

$$= \frac{1·5}{3·0} \times 100\%$$

$$= 50\%$$

Thus the moisture content of the piece of wood tested is 50%. A moisture content as high as this would indicate that the timber had been felled very recently and would therefore be unsuitable for using for a carving.

The Effects of Moisture Loss on Timber

It is obvious that timber can undergo great changes (Fig 4) as it dries out, and it is equally obvious that 'green' timber should never be used for sculptural purposes, as has been stated previously. Under ideal conditions the timber used for a piece of sculpture should have the same moisture content as the air surrounding the place where the finished object is to stand.

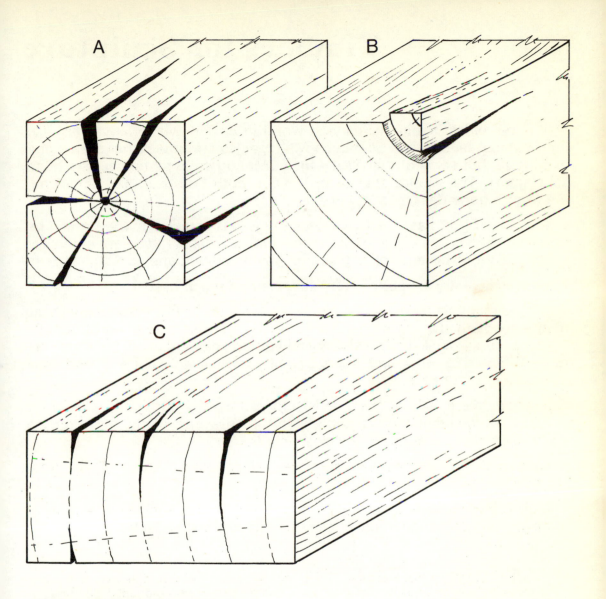

(A) **Heart shakes** (B) **Cup shake**.
(C) **End splits or checks**. (D) **Change of section;** may become diamond or rectangular in section, depending upon where the timber was originally situated in the tree.

Fig 4

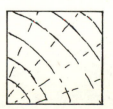
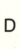

Timbers for Sculpture

Oak is the oldest traditional carving wood in Britain. Mahogany* has also long been in favour. The Caribbean Mahoganies are now rather scarce and expensive, but some of the West African Mahogany type timbers are quite satisfactory. The various species of Walnut, both European and American, are used a good deal.

The wood of fruit trees, particularly pearwood, is esteemed when it can be obtained. Cherry is another of our native timbers that is rated very highly for sculptural work, because of its beautiful golden colour, and its distinct grain.

Lime (the sculptor's wood) is very suitable and much used.

There are many hardwoods that can be used satisfactorily, particularly those in the medium density range. Some of the heavier — and consequently harder — hardwoods such as ebony and lignum vitae are used, but these are more difficult to work and these particular two are expensive and only available in small sizes.

Softwoods are mostly not very satisfactory. If a softwood is to be used for a piece of sculpture then it is preferable to use one of the slow grown softwoods with the annual rings close together.

A softwood that is good for carving is yellow pine (Quebec Pine) from North America.

The choice of wood is dictated by a number of factors such as appearance, the availability of wood in the sizes required, cost and so forth.

*It is interesting to note that there are two stories of how Mahogany was introduced into England. One theory is that it came in the form of a new rudder on the Golden Hind after the original one had been damaged on its voyage round the world. And the other belief is that a ship's captain, after visiting the various islands in the Caribbean, carried some back to England on his ship. This found its way to a cabinet maker who produced a writing desk from it. This was seen by the Duchess of Buckingham, who was so delighted with the effect that she had some furniture made of the same kind of wood. And from then on it became popular for the making of furniture and for carving.

Table of Suitable Timbers

WOOD	BOTANICAL NAME	SOURCE	FIRMNESS AND WORKABILITY	COLOUR	GRAIN	APPROX WT. IN LBS. PER CU. FT.
ALDER	Alnus glutinosa	G.B. and Europe	SOFT, working evenly and easily	Generally reddish	Indistinct to invisible	25 to 41
APPLE	Malus pumila	G.B.	HARD, can be worked well and easily	Red, often has brown pith flecks	Indistinct	20 to 40
BOX	Buxus Sempervirens	Europe and Asia	Requires sharp tools to work; HARD, dense	Yellow throughout	Scarcely visible	50 to 70
CHERRY	Prunus Avium	G.B. and Europe	HARD, but is readily workable	Golden brown	Distinct	20 to 40
EBONY	Diospyros	Africa, India Ceylon, Malaysia	Very HARD, difficult to work work	Black to greyish brown	Rather indistinct	70
ELM	Ulmus	G.B. and Europe	HARD, usually easy to work	Brown to reddish brown	Conspicuous	43
LIME	Tilia Vulgaris	G.B. and Europe	SOFT, easy to work	Yellowish	Obscure	30 to 42
MAHOGANY (AFRICAN)	Khaya spp.	West Africa	Rather HARD usually easy to work	Rosy brown to mahogany red	Apparent to obscure	35

WOOD	BOTANICAL NAME	SOURCE	FIRMNESS AND WORKABILITY	COLOUR	GRAIN	APPROX WT. IN LBS. PER CU. FT.
OAK (ENGLISH)	Quercus	G.B.	HARD, works fairly well	Yellowish brown	Obvious	45
OAK (SLAVONIAN)	Quercus	Yugoslavia	MILD, works fairly well	Yellow brown to deep warm brown	Obvious	45
PEAR	Pyrus communis	G.B.	HARD, works moderately	Pale reddish-grey	Obscure	45
PLUM	Prunus communis	G.B.	HARD, works fairly well	Reddish brown	Conspicuous	50
ROSEWOOD (BRAZILIAN)	Dalbergia	Brazil, West Indies	HARD, difficult to work	Red-brown to black	Visible	54 to 56
SYCAMORE	Acer pseudoplatanus	G.B., U.S.A., Canada, Cent. Europe	HARD, generally works easily	Whitish	Indistinct	35 to 45
TEAK	Tectona grandis	India, Burma, Siam, Java, N. Borneo	HARD, works moderately well	Yellowish brown to nut brown	Distinct	41
WALNUT (AMERICAN)	Juglans nigra	Cent. and E. U.S.A.	HARD, works easily	Greyish brown	Obscure	39
YEW	Taxus baccata	G.B.	HARD, works well	Reddish brown	Distinct	44
YELLOW PINE (QUEBEC)	Pinus strobus	E. Canada	SOFT, easy to work	Pale straw colour	Conspicuous	24

Table of Suitable North American Timbers

WOOD	BOTANICAL NAME	SOURCE	WORKABILITY	COLOUR	APPROX WT. IN LBS. PER CU. FT.
BASSWOOD	Tilia americana	USA, Canada	Soft, close-grained, easily worked	Creamy brown	26 to 30
BUTTERNUT	Juglans cinerea	USA, Canada	Soft, rather coarse-grained ; easily worked	Grey-brown to chestnut brown	28
CEDAR, RED	Juniperus virginiana	USA, Canada	Close grained, easily worked	Dull to bright pinkish-red	33
CEDAR, ALASKA	Chamaecyparis Nootkatensis	USA, Canada	Very close grain, easily worked	Pale yellow	31
CATALPA	Catalpa speciosa	USA	Straight, coarse-grained, soft	Light tan-brown or greyish brown	29
POPLAR, YELLOW	Liriodendron Tulipifera	USA	Heartwood carves exceedingly well	Light to moderately dark yellowish-brown with a greenish tinge	28
PINE, EASTERN WHITE	Pinus Strobus	USA, Canada	Soft, straight grained, delightful to work	Light creamy brown or tan	26
PINE, SUGAR	Pinus Lambertina	USA	Soft, easily worked	Creamy-white	25
REDWOOD	Sequois Sempervirens	USA	Soft, easily worked	Cherry-red to reddish-brown	30
SASSAFRAS	Sassafras Albidum	USA	Soft, straight, coarse-grained, easily worked	Grey to orange-brown	32
WALNUT, BLACK	Juglans Nigra	USA	Hard, carves well with chisels	Cocoa brown	39

These are just some of the woods grown in the United States and Canada that are suitable for carving and relatively easy to secure. Excellent sources of many suitable carving woods are firewood dealers and tree removers.

Tools and Equipment

Like most crafts, wood-carving is one which requires the use of a number of tools of varying sizes and shapes.

I would, at this juncture, like to stress that it is not all-important to have a comprehensive set of carving tools, or indeed all the auxiliary equipment.

Much of this can be improvised as one progresses with different carvings.

Carving tools — chisels, gouges, parting tools, and specials, may be purchased separately, or in sets comprising 6, 9, 18, 24, 36, 48, 60, 72 and 120 tools per set.

The chief kinds of tools are shown in Fig 5 and of these the straight gouge (A) will find its way into the hand more often than any of the others, as it is used for all general carving. The others are tools for particular purposes. For example, a curved gouge (B) may be used for hollowing. And for cutting a more acute hollow, the front bent gouge (spoon gouge) (C) would be used.

Gouges are catalogued by the curvature and width of the cutting edge — the curve or 'sweep', as it is called, can vary from almost flat to a deep U section.

Each 'sweep' shown in Fig 5N is available in different widths from $\frac{3}{32}$" to $1\frac{1}{2}$", the most popular widths being from $\frac{1}{8}$" to 1".

Chisels are available with either a square or a skew cutting edge. They are used mainly for setting in, the skew chisel being useful for reaching into acute corners. The bent chisel is an invaluable tool for recessed work.

Sizes of chisels range from $\frac{1}{16}$" up to $1\frac{1}{2}$".

When purchasing carving tools one has a fairly wide choice for, as well as the many different shapes and sizes, one also has the option of buying tools handled, or unhandled. But unless you are competent to turn and fit your own, then the obvious thing to do is to purchase your carving tools with handles fitted.

These may be made from Ash, Beech, or Boxwood. The shape may be either round or octagonal, the latter giving a better grip, as well as preventing the tool from rolling off the bench.

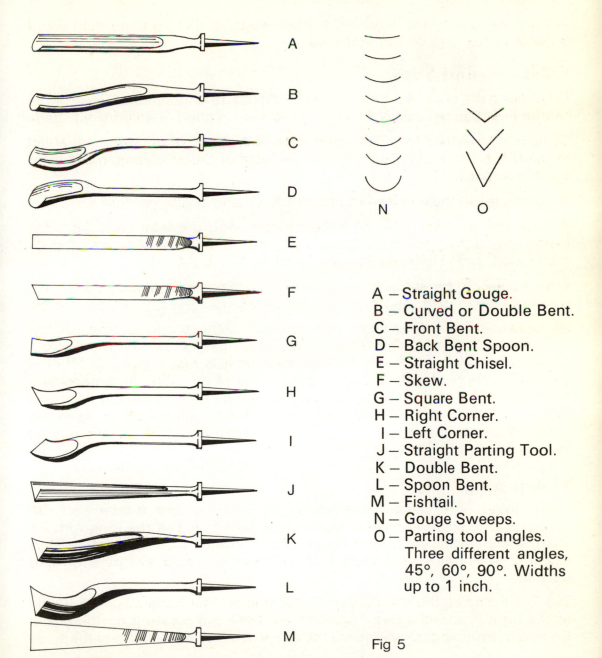

A — Straight Gouge.
B — Curved or Double Bent.
C — Front Bent.
D — Back Bent Spoon.
E — Straight Chisel.
F — Skew.
G — Square Bent.
H — Right Corner.
 I — Left Corner.
J — Straight Parting Tool.
K — Double Bent.
L — Spoon Bent.
M — Fishtail.
N — Gouge Sweeps.
O — Parting tool angles.
 Three different angles,
 45°, 60°, 90°. Widths
 up to 1 inch.

Fig 5

Which to select? Well, that will depend entirely on the type and size of carvings that you are going to undertake.

For general use by the beginner, I would suggest that no more than about 9 cutting tools should be purchased.

Oilstones and Slips

Oilstones and slips are very essential pieces of equipment. Good work cannot be produced unless the cutting tools are in good condition and sharp.

They may be natural quarried stones such as Washita, or Arkansas, (quarried in the U.S.A.) or artificial stones such as India or Carborundum, made in an electric furnace.

All of these can be obtained in fine, medium, and coarse grades.

Wedge shaped 'slips' (Fig 6) used for removing the wire-edge from the inside of gouges, parting tools etc, are available in the same makes already mentioned, and in different sizes and shapes. (Fig 6 B C D).

If not exactly of the shape or curve required a slip can be rubbed down on a piece of marble with sand or carborundum powder and thin lubricating oil.

Stones should be kept as clean as possible at all times, and to facilitate this, an oilstone (a size of 8″ × 2″ × 1″ is about right) should be fitted into a wooden box with a lid (Fig 6A) as soon as it is taken into use. The oil (thin lubricating oil) which prevents the pores of the stone from becoming clogged as well as dissipating the heat caused by friction, should be wiped from the surface of the stone before it is covered after use. To keep the shaped slips clean and in working order, I have found it best to wrap them in an oily rag.

Sharpening

One should never regard sharpening as being a time-waster; on the contrary, time spent in sharpening tools is time saved in the long run, for sharp tools cut far easier and faster, and of course more accurately. Persevering with dull-edged tools will only lead to sheer exasperation and despair.

Fig 7A illustrates the sharpening of the gouge. The handle is held lightly in the right hand, with two fingers of the left hand pressing on the blade. Commence rubbing up and down the stone in a figure-of-eight, at the same

(A) **An oilstone,** fitted into a wooden box with a lid, keeps the stone clean and in good working order.

(B) **Gouge slip.** Available in different sizes.

(C) **Graduated gouge slip.** This is very useful for large gouges.

(D) **Slip shapes to suit V-tools.** May be obtained in different sizes and angles.

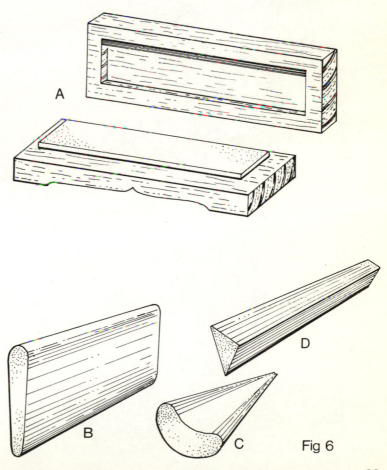

A

B

C

D

Fig 6

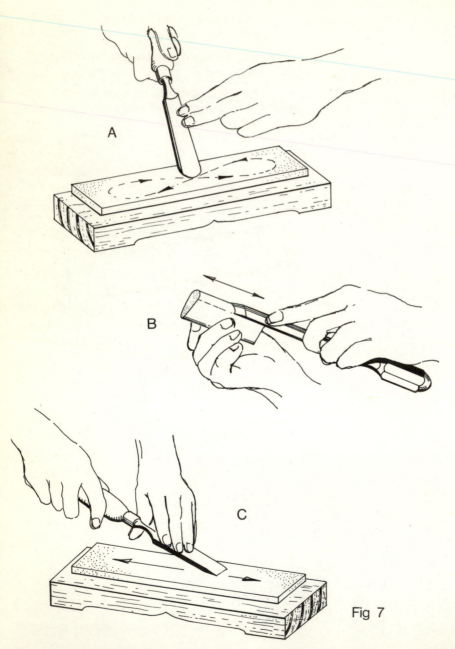

A

B

C

Fig 7

time making a rotational movement with the wrist. The reason for this rather complex sharpening action is to bring all of the cutting edge into contact with the stone. When the outside edge is satisfactory it is then necessary to remove the burr from the inside by using a slip with a curvature to suit that of the gouge, Fig. 7B.

Sharpening the chisel will prove to be a fairly straight-forward task by comparison. But I hasten to point out that all the narrow chisels should be kept to the outer edge of the stone when sharpening, otherwise in a short space of time you will end up with a hollow stone.

Sharpening the 'V' or parting tool is really a combination of the last two mentioned, inasmuch as the outside edges of the 'V' are sharpened like the chisel, and the burr removed (like the gouge) from the inside, with a V shaped slip to suit the internal angle of the tool.

After the initial sharpening on an oilstone, a keener cutting edge can be obtained by stropping the tool on a piece of leather that has been dressed with a mixture of oil and very fine emery powder, or, fine grade emery paste.

For chisels and the outsides of parting tools, a piece of leather fixed to a flat board will suffice. But for the inside of the gouges the leather will have to be fitted to shaped blocks of wood similar in section to the oilstone slips. The action for stropping is to drag the tool backwards, the gouge being rotated at the same time in order to cover all the cutting edge.

Never go forward with the tool or you will end up by cutting and spoiling the leather.

Saws

Handsaws (Fig 8A) may be divided into two main groups, rip saws for cutting with the grain and cross-cut saws for cutting across the grain. The difference between these two lies in the shape as well as in the sharpening of the teeth (Fig 8B ; C). B illustrates the shape of the teeth on the rip saw. The distance between the arrows indicates the number of points per inch. The shape of the cross cut teeth can be seen at C.

Rip Saws. These saws are used for cutting with the grain only and will tear the wood rather badly if used for cross cutting. The average rip-saw is 24" long with 5 points to the inch.

Cross Cut. As the name implies, is used principally for cutting across the

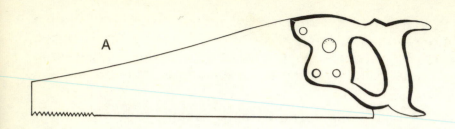

A

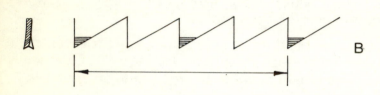

B

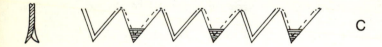

C

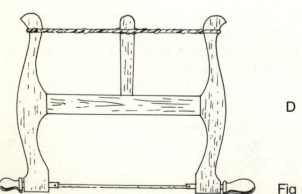

D

Fig 8

grain of the wood. Size of teeth varies from six to twelve points, and lengths from 22—28 inches.

Variations exist of these two main types: for example the Half-Rip is a compromise between the two, and which may be used for cutting either with or across the grain. The panel saw is another variation, which is similar to the cross-cut but with much finer teeth.

These last two mentioned are by far the most useful saws to have included in one's tool kit.

A word of warning — saw sharpening and setting is very difficult. My advice is to have it done by an expert.

Bow Saw. (Fig 8D) This saw is used for cutting curves. The blade, which is held in tension by twisting the cord tourniquet fashion, may be turned to any convenient angle to accommodate the work in hand. The bow-saw is used with both hands on the same handle.

Extra Tools

Apart from the essential tools, there is a vast range of others that would prove extremely useful additions to your tool kit. Such as, a 6 feet flexible rule; a 6 or 12 inch try-square; a pair of dividers; a compass (with pencil and divider attachments); two screwdrivers, one large (about 10 inches) and a smaller one (about 5 inches in length); a woodworkers brace and a selection of bits; a Surform shaper, Fig 9A; a couple of wood rasps, Fig 9B; a selection of riffler files, Fig 9C; and lastly, a smoothing plane, Fig 10 a 'must' if you intend to mount your sculptures on 'squared-up' bases.

The Work Bench

A strong bench on which to work is yet another essential for the carver to consider. And as this piece of equipment is more of an individual problem, I shall endeavour to generalise and yet cover the salient points.

The bench should have a good thick top (not less than 2" in thickness) of beech or similar hardwood as opposed to one of softwood. The under-framing should be equally stout, and joined together by strong mortise and tenon joints. The whole structure should be rigid; and to help this, diagonal cross braces could be added. Two suitable benches are shown in Fig 11.

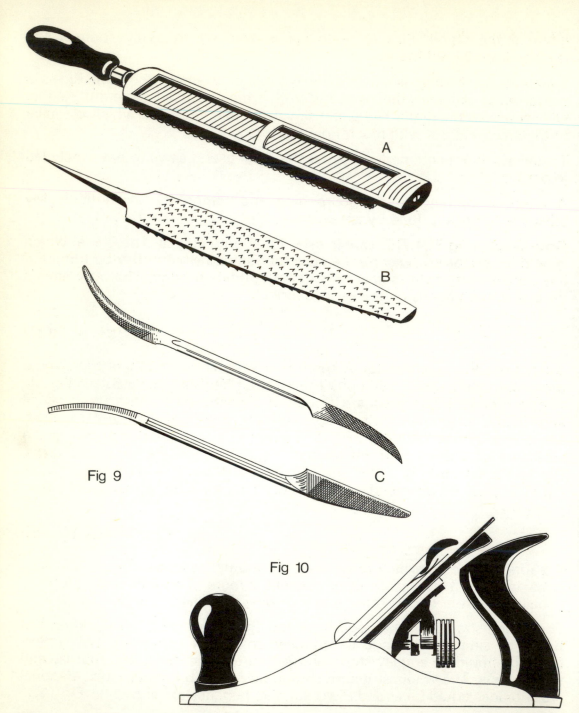

A

B

Fig 9

C

Fig 10

Fig 9 Useful shaping tools

(A) **Surform Shaper.** This is a tool that has become very popular in recent years. The blade is so designed that the teeth allow for the clearance of the cuttings, unlike the rasp which tends to 'clog', necessitating the use of a file card (a short wire brush fixed to a block of wood) at regular intervals to remove the 'packed' waste. The Surform has a cutting action that is both quick and safe, and it is therefore an ideal tool for use by children. (See Sculpture by Children, plates 66 to 71). Shapers may be obtained in many different types and shapes, and all with replaceable blades, thus giving the tool a long and efficient life.

(B) **Wood Rasp.** These are obtainable in round and half-round shapes, with lengths varying from 6 inches to 16 inches. As well as these variations in section and length, rasps are graded according to their cutting action; we have the roughest cut which is the 'Bastard' and the medium or 'Second-Cut' and lastly the 'Smooth'.

(C) **Riffler Files.** These are very fine cutting and are made in many shapes to suit various curves, and are ideal for finishing off in difficult places or where a cutting tool is tending to tear at the grain of the wood.

The Smoothing Plane illustrated in Fig 10 is available in different sizes, this being determined by the width of the cutting iron (blade). The most useful size, and the lightest (for this type of plane is often used with only one hand), is one having a 2 inch cutting iron.

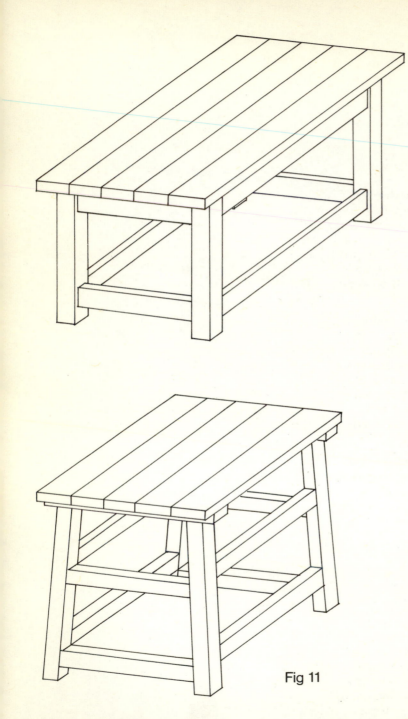

Fig 11

If you intend to do your carving from a seated position then a bench height of from 26–32″ will be needed. But if on the other hand you will be carving from a standing position (and this I strongly advise you to do, as it allows more freedom of movement) then a bench height somewhere between 36 and 42″ will meet the case.

The size of the top will depend to some extent, on the floor space available; a good size (if you can manage this) is 2′ 6″ wide and 4′ long; remember, there are many tools that could be laid out on its surface as well as the carving in hand.

When positioning the bench in the workshop or studio, the following points should be considered:—

(1) that the floor is firm enough to support the bench, and to permit heavy chopping.

(2) that there is sufficient working space round three sides of the bench.

(3) that there is a good natural light falling on the bench. And a strong electric (adjustable) light for use during the hours of darkness, as well as supplementing natural daylight on dull days. Good lighting will ensure more accurate work, and less eye-strain.

Holding Devices

When a piece of wood is being carved, it is imperative that there is no free movement of the timber, for not only would it make carving more difficult, and less accurate; but would also make the task of cutting the wood more hazardous. If the work is not secured properly to the bench there is a strong temptation to try and steady this with one hand at the same time trying to carve with the other. (See notes on Safety Precautions, page 122).

The main reason for cramping the wood down securely to the bench is to allow the carver full use of both hands. One or more of the cramping devices shown in Fig 12 may be used for this purpose.

The Vice (A) available in many sizes and with or without a 'quick release' mechanism, is secured to the underside of the bench by bolts, the heads of these being sunk below the working surface and the holes filled with wooden plugs. The jaws of the vice should be fitted with wooden linings in order to prevent the carving from being bruised.

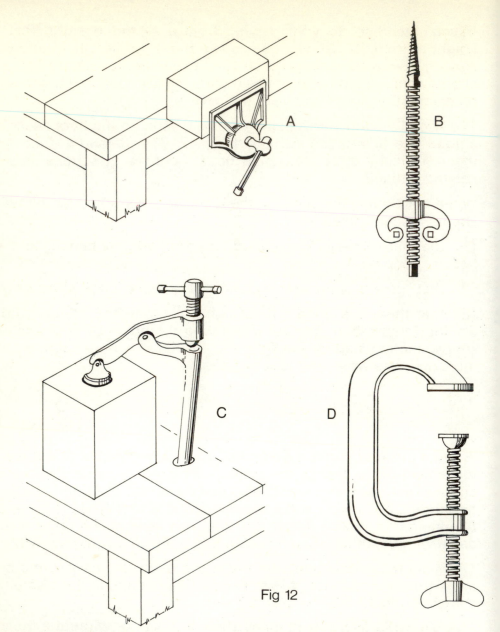

Fig 12

The above illustrations show four items of equipment that are used for holding the wood securely to the bench, while it is being carved.

(A) **Vice.** The jaws are usually fitted with linings to protect the carving.

(B) **Carver's Screw.** (C) **Bench Holdfast** (D) **G-Cramp.**

The Carver's Screw (B) is used for holding a block of wood firmly to the bench. The screw-threaded (pointed) end is driven into the base of the piece of wood to be carved and tightened by using the wing nut as a spanner (a set spanner of the correct size will give more leverage). The end of the screw (the square end) is then passed through a hole in the bench top and the wing nut threaded back on and tightened from beneath. With this method of fixing, pieces of wood with a hole the diameter of the screw, drilled right through and threaded on, are useful for raising the block to be carved to a convenient working height.

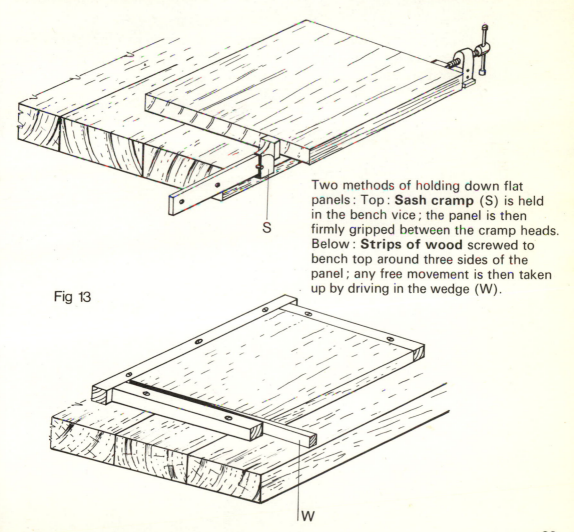

S

Two methods of holding down flat panels : Top : **Sash cramp** (S) is held in the bench vice ; the panel is then firmly gripped between the cramp heads. Below : **Strips of wood** screwed to bench top around three sides of the panel ; any free movement is then taken up by driving in the wedge (W).

Fig 13

W

The Bench Holdfast (C) consists of a wrought iron pillar with a pivoted lever, which can be adjusted by turning the steel screw. The pillar is threaded through a metal-lined hole in the bench top. The swivel pad on the end of the lever is placed on the work and pressure applied by turning the screw until the work has been secured.

The G-Cramp (D) is also used for holding work down to a bench top while it is being tooled. Sizes range from 3 inches to 12 inches (fully opened). The bench holdfast and the G-cramp are useful for holding flat panels whilst working on relief carvings. Other methods of holding down flat panels are illustrated in Fig. 13.

When using cramps, it is advisable to place a scrap piece of wood between the work and the shoe of the cramp. This prevents any damage or marking of the surface of the work.

NOTE ON AMERICAN TERMINOLOGY:
 Vice = Vise
 G-cramp = C-clamp

Using the Carving Tools

In the early stages of a carving the 'Bosting in', in which the main form alone is considered, is worked with the mallet (the best type is the round form, Fig 14A) and gouge ; the gouge should be as large as is convenient, keeping to this tool except for places which are too small for it to reach. Generally you will find the cutting much easier if you use the gouge across the grain of the wood. If the gouge is driven too deeply into the wood through excessive use of the mallet, on no account should you try to lever it free – this could cause irreparable damage to the tool as well as the carving. The only sure way is to cut away the wood around the wedged tool carefully with another gouge until it can be freed.

In the finishing stages and for certain delicate passages of a carving, the mallet is no longer necessary, as can be seen in plates 2 and 3.

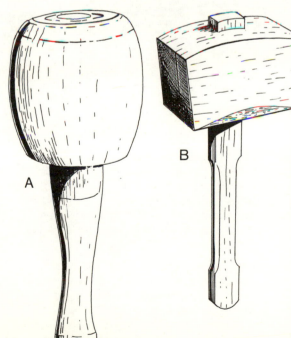

A B

Fig 14

Wood Carver's Mallets (shown at A on left) may be purchased with heads made from beech, lignum vitae, and sometimes hickory, with (in most cases) handles made from ash. Various weights are available, but for general use I suggest that you buy a 14 oz mallet with a beech head. Or perhaps you could turn your own, if you have access to a woodturning lathe.

For my own use, I have a 7 oz and a 14 oz carver's shape, as well as a 2 lb bench mallet, (B). All of them made from beechwood.

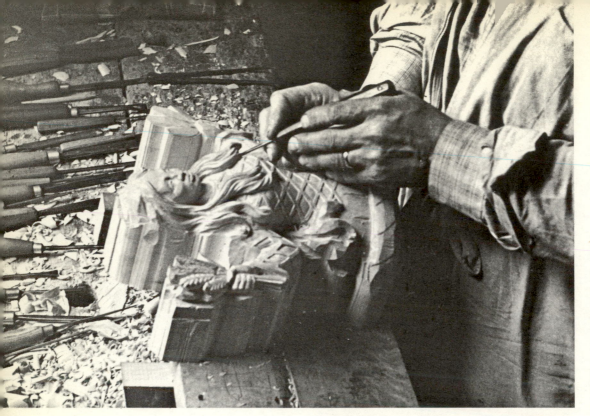

Plate 2

Carving — a negress holding barley sheaves.

Carved in Lime.

For the Brewers Hall, London.

The tools are best laid out in a row at the back of the workbench, with the blades towards you. This will enable you to select the shape you require and at the same time allow the hand to be placed on the tool in the right position for working.

When using the tools for delicate passages in the carving, the forward pressure is provided by one hand, whilst the other hand guides the tool, at the same time tending to pull back from the cut, so preventing the tool from over-shooting.

Plate 3

Here, the gouge is held in the left hand, with the thumb along the handle — this gives greater control over the tool, which tends to rotate. The gouge is then gently tapped with the palm of the right hand.

These two methods of holding the tools, obviously, will come more naturally with practice.

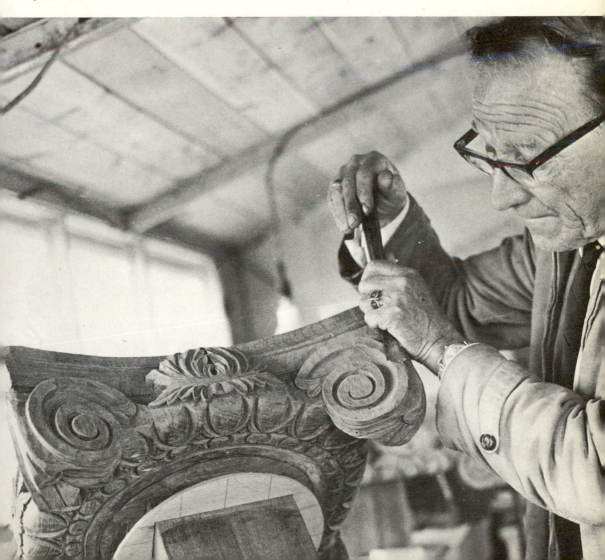

Carving a Bear

> 'And taking the very refuse thereof which served to no use,
> A crooked piece of wood and full of knots,
> Carveth it with the diligence of his idleness,
> And shapeth it by the skill of his indolence.' The Wisdom of Solomon

Every sculptor has his own method of working, and most students usually find that whatever way they have been shown, they will eventually work out and develop methods of working most suited to themselves. Therefore this section (Carving a Bear) illustrates only one of many ways in which the job may be executed.

I have chosen a simple but decorative animal form that should present little difficulty to any beginner.

As in all sculpture in the round, the work passes through three main stages; an elevational (side) shaping in which the main outline is cut through square, followed by a second elevational shaping (in this case it is a plan view) — again, this is cut through square, thus producing the main outline of the animal; (Plate 3) the rounding or bosting-in, in which the rough, general shape is formed; (Plate 4) and finally the finishing.

Stage 1

A full size drawing is needed first, showing a side elevation and a top view. On a sheet of thin card rule up a series of squares as in Figs I and II, in this section, and plot in the shapes map fashion. The carving may be done to a larger or smaller scale if required, simply by increasing or decreasing the size of the squares.

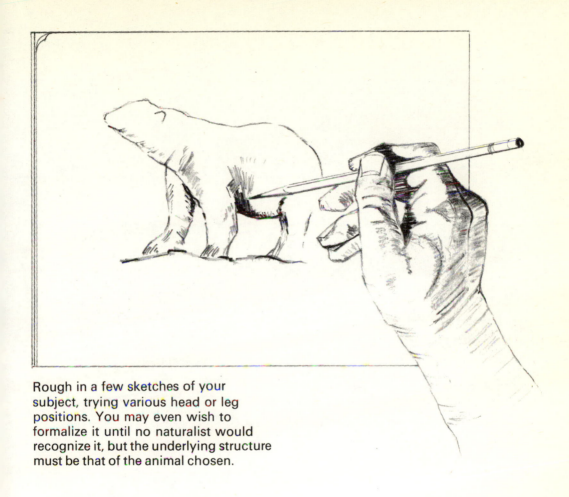

Rough in a few sketches of your subject, trying various head or leg positions. You may even wish to formalize it until no naturalist would recognize it, but the underlying structure must be that of the animal chosen.

A block of wood 6½ in. by 3 in. by 3 in. is needed to suit the ½ in. squares that I have drawn. The block is squared up and the ends trued. To mark out the shape onto the wood, take the drawing on the card and cut out the side elevation and use as a template, holding this on the side of the wood and drawing round the outline. The top view is also marked out in this way (Fig III). An alternative to this is to trace off the required shapes from the drawing and transfer these to the block of wood; the image can be lined in more heavily once the tracing paper has been removed.

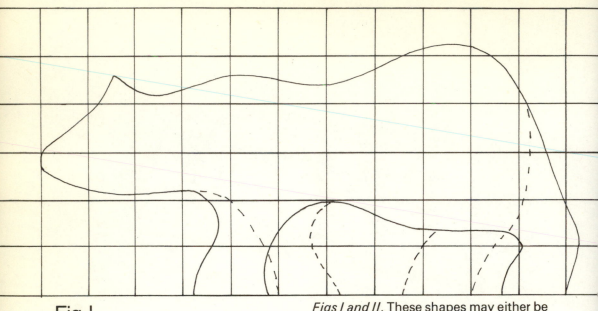

Fig. I

Figs I and II. These shapes may either be cut out and used as templates or traced off the drawing and then re-drawn onto the block to be carved.

Note that the tip of the nose touches the same vertical line on both drawings.

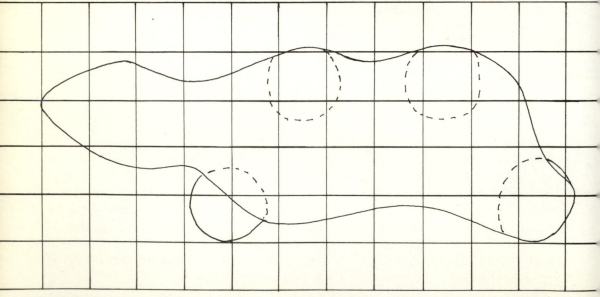

Fig. II

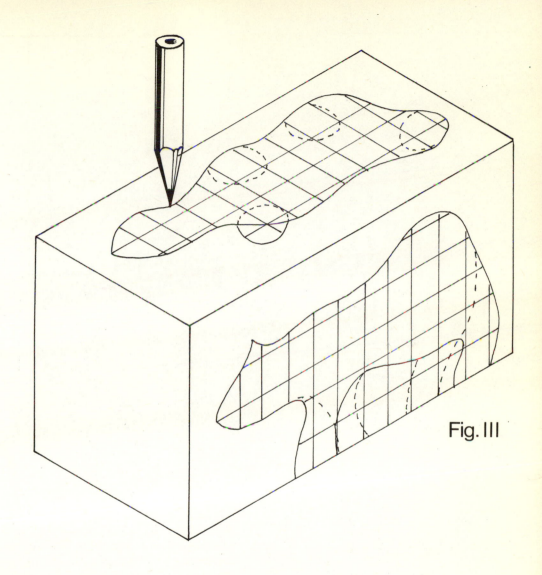

Fig III. The cut-out shapes being used as templates for the marking out of the block.

When positioning the templates, ensure that the tip of the nose on the plan view is the same distance in from the end of the wood as that on the side elevation.

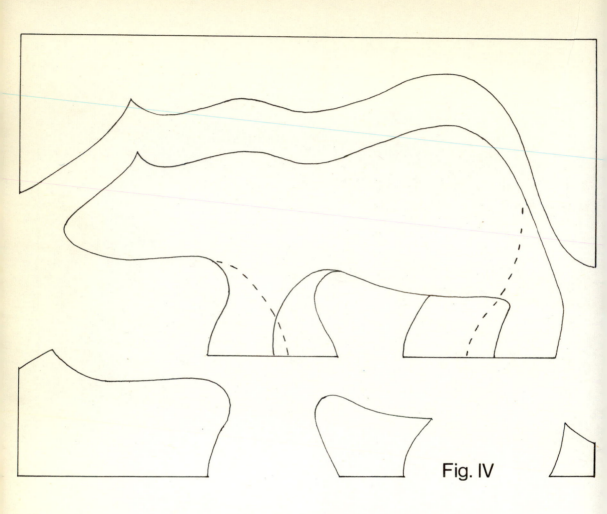

Fig. IV

Fig IV. This illustration shows the first elevational shaping. When cutting the top waste it is necessary to cut from each end of the block and meet at the 'point' of the ear.

Fig V. This shows the top view of the bear after it has been sawn. Like the cutting of the side elevation, it is necessary to work the bow saw from each direction if difficulty is encountered in tight corners.

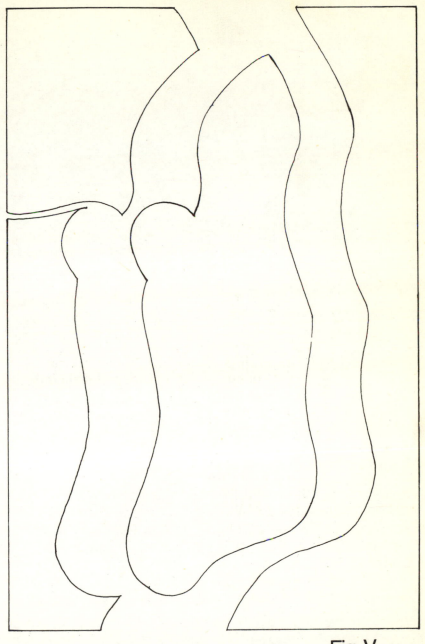

Fig. V

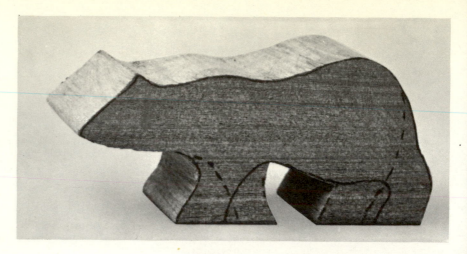

Plate i

This shows the outline carefully shaped with the aid of a bow saw. It must be added here that this thickness (3 inches) is about the maximum that can be cut with this type of saw; anything greater than this and the removal of any waste wood will have to be executed with a mallet and gouge.

Notice the broken lines indicating hidden detail, i.e. the far side of the work.

Stage 2

The removal of the waste wood on the side elevation is done with a bow saw, thus revealing a true outline, see Fig IV and Plate i. At this point it is necessary to remove the waste belonging to the legs on the far side; this should be chopped back to about half way across the block with a mallet and gouge (Plate ii). The same may be done from the opposite direction, again chopping to half way across the block. This, then, gives the approximate position of the four 'paws' as seen on the drawing (Fig II).

Whilst the bottom pieces of waste wood may be thrown away, it is necessary to retain the top piece as this has the true plan view on it; this can be sawn to shape and then used as a template to mark out the top view onto the, now, undulated back of the bear.

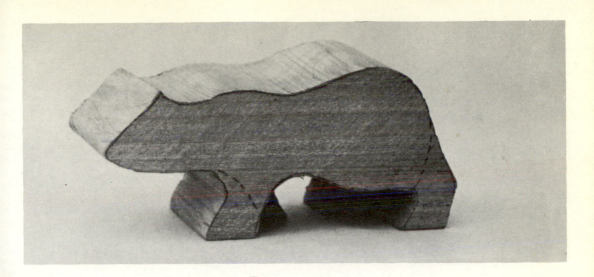

Plate ii

Here the far legs have been cut back with the mallet and gouge to about half way across the thickness of the work. This is done simply by gripping the shape in the vice with the legs uppermost; this allows the waste wood to be chopped away quite easily, although care must be taken to ensure that the gouge does not slip and cut into the 'wanted' portions of the legs.

The outline of the plan view is then cut to shape (Fig V) with the aid of the bow saw; an alternative method of removing this waste is to cut a number of saw cuts across the grain and up to the outline, and then chop away the waste with chisel and gouge.

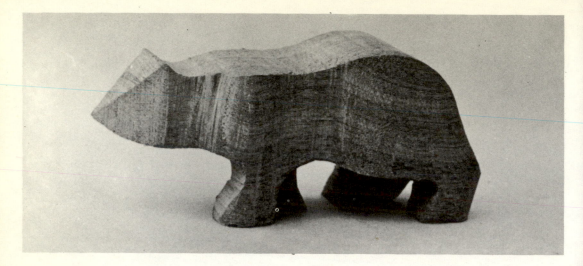

Plate iii

Before work began on the shaping of
the sides, the leg waste on the far side
was removed, again to half-way across.
When this stage is reached it is necessary
to take extra care when holding the
work in the vice, as the short-grain
across the legs is susceptible to
splitting if pressure is applied in the
wrong place.

Stage 3

Our bear is now beginning to take shape (Plate iii) but it still has that
square look about it: so we now proceed to round off the main form
(Plate iv) at the same time working in the heavy muscular appearance that
one associates with this animal. This final shaping and smoothing-off,
which is done mainly with rasp and file and then with glasspaper, must be
done with a great deal of discretion as any unnecessary or 'out-of-place'
undulations would very much spoil the finished sculpture.

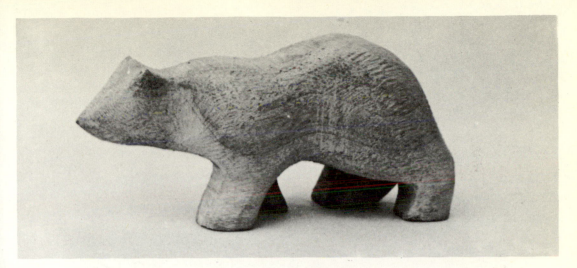

Plate iv

Here we see a general rounding in of the shape, this being done with a 'medium cut' rasp. This work may also be executed with gouges of a rather flat sweep if a 'tooled' finish is required (see the bear in Plate 57).

It is essential at this stage to have a good side or top lighting in order to reduce the risk of creating unnecessary undulations.

Stage 4

At this stage we have reached a point where the shaping is complete, and the sculpture is smooth and sleek from the use of very fine glasspaper.

We now have to consider the type of finish or protective coating that we should apply. The main reason for the application of a suitable polish is to protect the wood from becoming dirty, particularly if the wood is of a light colour; moisture also must be kept out, and the only way to ensure this, is to use some form of polish or oil.

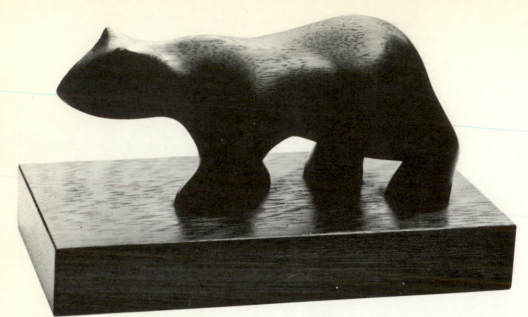

Plate v

The bear, now complete of all necessary shaping of its forms, has been smoothed-off, and given a coat of polish to seal the surface of the wood; this was then followed up with steel wool and beeswax, the surface being rubbed down until a smooth even polish resulted. Not only does this protect the surface from the effects of dampness and collective dust, but it also enhances the grain of the wood. The finished sculpture has been mounted onto a simple base, which helps to emphasize the forms of the animal as well as safeguarding the legs from being broken.

Notice how the bear has been positioned, with the hind legs fairly close to the end of the block, thus creating a good balance between base and sculpture.

To finish this piece of instructional sculpture I have used a polyurethane varnish to seal the surface of the wood. I must stress at this point that the aim is not to produce a very high polish, as this has a rather commercial appearance about it; any high gloss that might result with the application of such polishes as the above mentioned, and also the cellulose lacquers and French polishes, will have to be cut back by the use of steel wool and soft beeswax, the latter being used somewhat as oil is used for the sharpening of gouges, i.e. to collect and float away the small particles that have been removed by the grinding action. Once the surface has resumed its original smoothness, the waxed surface should be left to harden for about half an hour or so and then burnished off with a soft cloth. It will be found that a smooth and even silk-like polish will result.

In conclusion I would like to say this — no book on wood sculpture, however comprehensive, could ever cover all the aspects of carving, this is something that only years of practical experience could achieve. So, in this section (Carving a Bear) I have dealt with the subject in a very elementary way, this being done for two reasons; in the first place, to give the complete beginner an easy approach to carving due to the large amount of shaping that may be done with the bow saw and rasp, and so eliminating the otherwise necessary use of many carving tools; and yet, at the same time, giving him a chance to get the feel of the wood, a material that can often prove to be a trial even to an expert. And secondly, I feel that even the most ham-fisted beginner would make a successful piece of sculpture by this method, and so find the inspiration, and an exciting urge to go on and do more and more carvings, developing his own technique in the process.

The Base

For some pieces of sculpture, it will be necessary to design some form of base upon which to stand the finished work, see Plates 22, 60. On others it may be that the design of the piece of sculpture is such that a base may be formed as an integral part of the carving and cut from the same block, Plates 8 : 11 : 51 : 56 : 58.

Many carvings are marred by the base upon which they stand. For instance, a tall carving may have been mounted on a very thin base, thus creating an unbalanced effect, whereas if a thicker or taller block had been used this would have emphasised the height of the piece of sculpture, at the same time making a more proportionate union of base and carving.

A rather complex carving that may have a lot of curved surfaces or angular planes, could be enhanced by being fixed to a very simple base. See Plate 4.

Try standing your work on a box or block of wood of a suitable size for the carving, to see how it looks — stand it on many things; a building brick (if the size be right), a couple of books, a slab of stone or slate, in fact anything that will give you a variety of shapes and sizes. Only by experimenting in this way will you arrive at a suitably designed base.

Waxing and Polishing the Surface

When a carving has undergone its final cut or last rub of glasspaper, there always follows a reluctance to do anything more to it, other than just put the finished article on display. For wood that has been crisply carved with great care, or finished with a very fine glasspaper, rendering the carving all sleek and smooth, one feels that there can be no further improvement. This of course is largely true; but the aim is not to improve that which is already perfect – but merely an attempt at preserving this perfection.

The reasons why we must apply some form of protective coating, then, are as follows:

1 To prevent finger-marking.
2 To prevent discolouration from dust.
3 To protect the wood from climatic changes.

We can only protect the surface of wood if we polish the work (indoor sculpture only) with a wax polish.

The wax is prepared by cutting up pieces of beeswax into a clean tin and covering with turpentine (or turps substitute). Gently heat this by placing the tin into a saucepan of hot water, continue to heat until the beeswax is thoroughly melted. This should then be left to cool, and then applied sparingly to the surface of the carving with a piece of clean cloth. Leave it for about half an hour and then rub the surface with another piece of clean dry cloth. This will produce a nice even polish.

Two other ways of using wax polish are:

1 Give the surface of the carving a coat of raw linseed oil first. When this has soaked in and the surface is thoroughly dry apply the wax as described above.
2 Give one or two coats of 'brush polish' (French polish thinned with methylated spirit, or, one of the polyurethane polishes thinned with turpentine). When dry (about 1 hour for French polish, and not before 6 hours have elapsed for the polyurethane) rub the surface vigorously with steel wool and wax, then clean off with a dry cloth and a smooth even polish will result.

Successive rubbings of raw linseed oil is yet another method of protecting the surface of the carving from dirt and climatic changes. This is much slower than waxing but can be very effective.

Developing Your Idea

The development of your idea or inspiration will most probably start off in the form of a 'pictorial note', perhaps on some scrap of paper that may be to hand — this first idea must be lived with, and turned over in your mind for some time, before any attempt is made to shape up the work. This is important; for it ensures that the project is well fixed in your mind, and that you are setting out on course.

Some craftsmen can work direct from a rough sketch and make an excellent carving, whereas others may have to clarify an idea by producing a better drawing, perhaps a 'full size' one on squared paper showing front and side elevations; some would even take this a step further and make a model of the sculpture in Plasticine or clay — this of course does have the advantage over the sketch or drawing inasmuch as a piece of intricate modelling can be shown more easily on the reference model than on any drawing.

There are many things that can inspire one to carve — I will venture to say that other people's work has the strongest pull for inspiration. By this I do not mean you must just copy other people's work. Far from it. But, seeing good work done by others has (in my opinion) this inspiring quality.

Visits to art galleries and museums will give you a chance to study historical as well as contemporary works by other artists and craftsmen. Whilst on any such visit, you should never be afraid to take out your sketchbook and pencil and jot down any points worth noting, (and you will find many), for these will surely prove to be useful at some later date on your own carvings.

As you will soon learn, inspiration can come from all manner of objects such as rocks, pebbles, bones, trees, sea shells, etc. In fact Henry Moore himself has found principles of form and rhythm for some of his works, from the careful study of these natural objects.

Examples of Sculpture

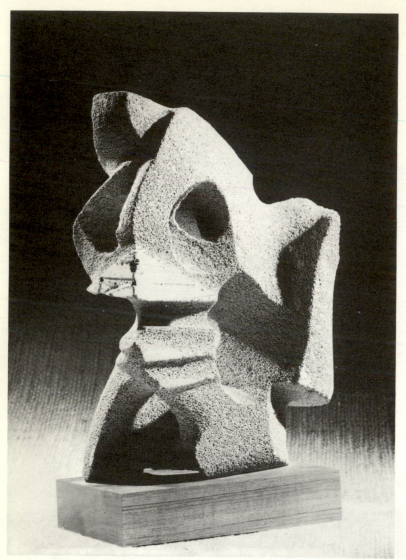

Plate 4

Although this sculpture is not one from wood, it serves to illustrate the need of a simple base in order to enhance a complex sculpture.

Sculpture by Michael Smith.

(photo : Edward Leigh, F.I.B.P., F.R.P.S.)

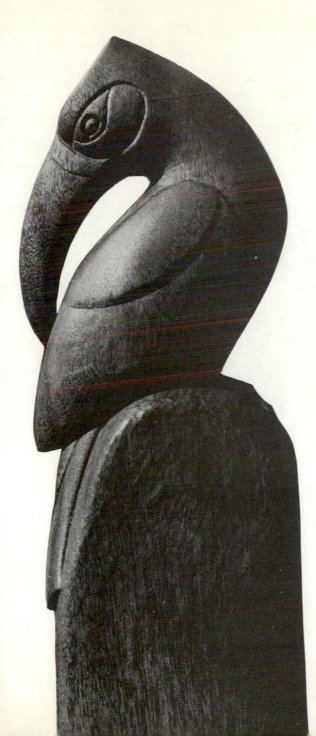

Plate 5

NANCY CATFORD. Toucan, carved in
Mahogany. Height 10 inches (254 mm).

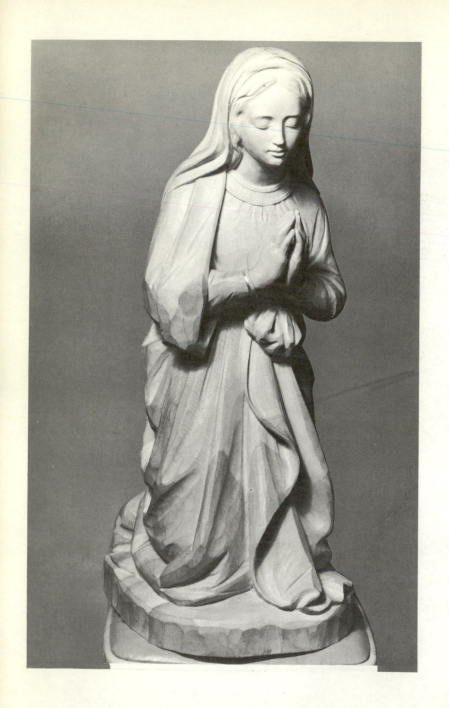

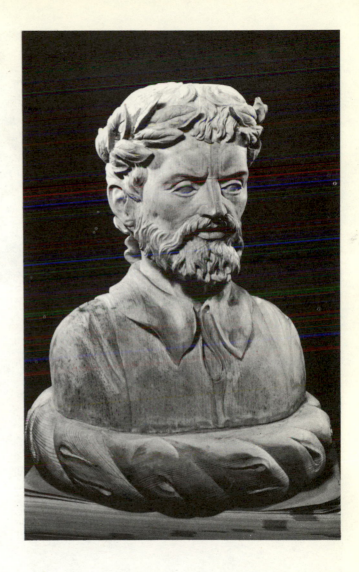

Plate 6

GINO MASERO. Madonna, carved in Quebec pine, height 28 inches (711 mm). Part of a crib set for St. Mary's Hampstead. An excellent example of technique, illustrating particularly well the garment folds and the importance of accentuating a change of plane by making the angle more acute.

Plate 7

GINO MASERO. Crest for a Helmet, Quebec Pine. Height 16 inches (406 mm).

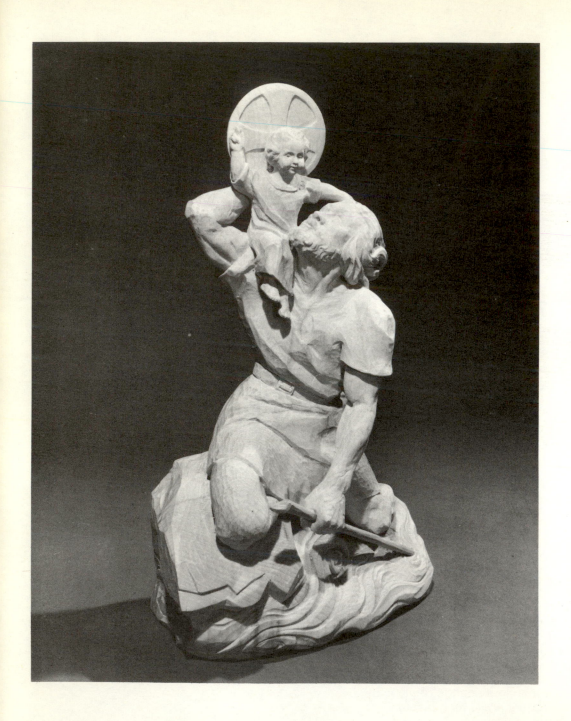

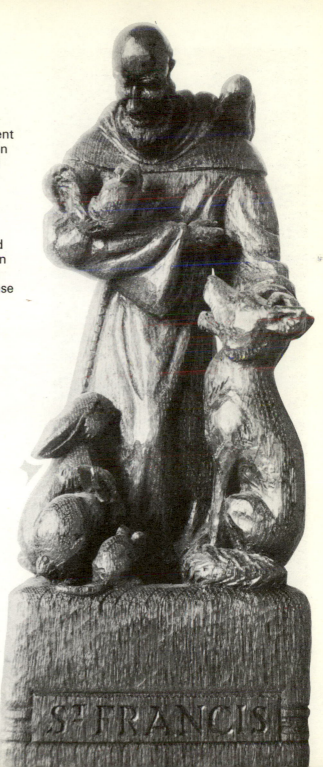

Plate 8

GINO MASERO. St. Christopher, Quebec pine, height 18 inches (457 mm). The surface treatment here is a very well executed gouge-cut finish (compare this with the surface treatment of the Madonna, Plate 6). The direction of these gouge cuts can often be used to accentuate form and texture.

Plate 9

NANCY CATFORD. St. Francis, carved in oak. Height 16 inches (406 mm). An example of the use of incised lettering as a means of embellishment to the base of a sculpture.

St·FRANCIS

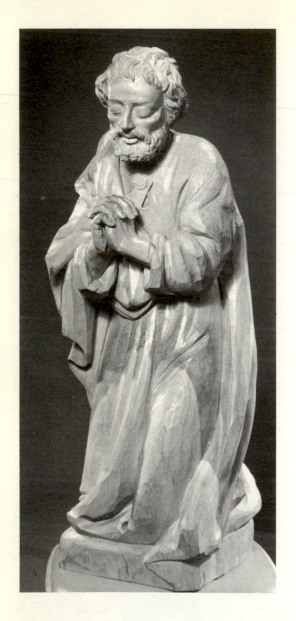

Plate 10

GINO MASERO. St. Joseph, carved in Quebec pine, height 30 inches (762 mm). Part of a crib set for St. Mary's, Hampstead. Notice how the technique has been suited to the material. If this was a figure made from clay or stone the lines would be more carefully rounded, and, consequently, a less distinctive play of light and shadow would be evident. But wood in itself suggests angularity and geometrics, so the sculptor here has followed this to its conclusion and accentuated the fact that the medium used is that of wood.

Plate 11

GINO MASERO. Shepherd, carved in Quebec pine, height 30 inches (762 mm). Part of a crib set for St. Mary's, Hampstead. It will be noticed that the eyes on this figure are open and that they appear to be sightless; this is a technique that goes as far back as the Ancient Greeks.

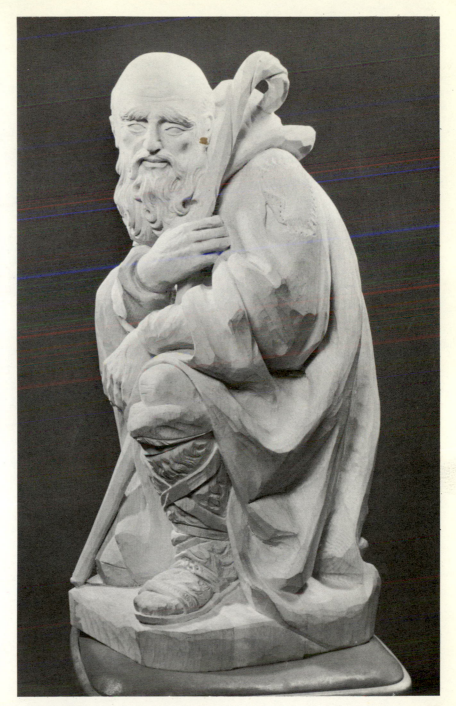

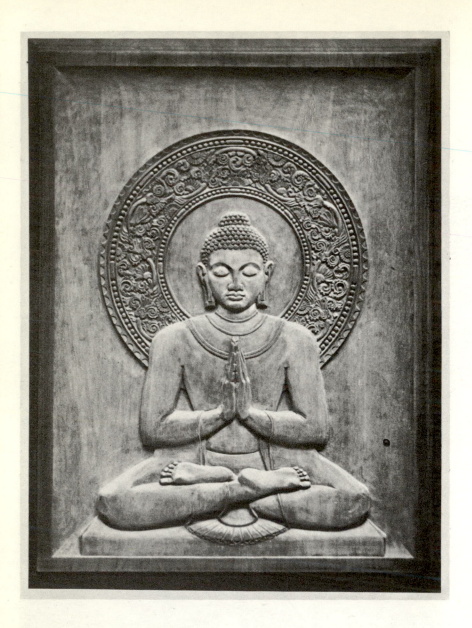

Plate 12

GINO MASERO. Buddha, Teak. Height
48 inches (1219 mm). This is a fine
example of sculpture in relief, in which
the subject is almost void of a third
dimension; at least in the low, or bas-
relief (shown here). However, a high or
full relief carving would have much
greater depth, in which the subject
would be worked to about three-
quarters of its third dimension. (See
Plate 13).

Plate 13

ROBERT W. FORSYTH. St. Joseph the
worker, a full relief carving in Slavonian
oak. Height — life size.

Installed in the Church of St. Charles
The Martyr, Portland, Oregon, U.S.A.
in 1963.

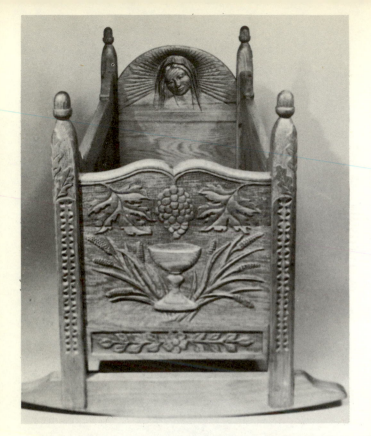

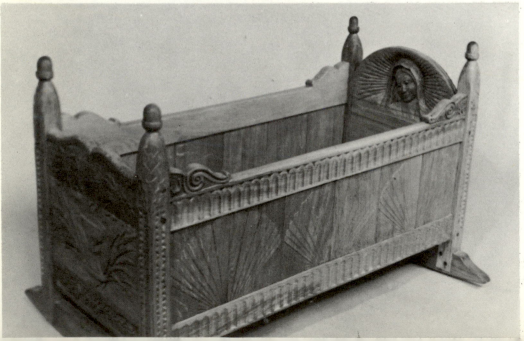

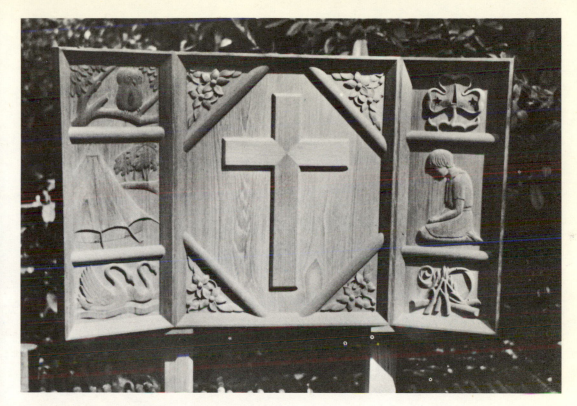

Plate 16

Girl Guide Altar, carved in Teak. A
further example of relief carving. Take
particular notice of the well-balanced
layout of the panels. Framed work, like
this, requires a high degree of skill.
(Courtesy W. J. D. Clarke).

Plates 14–15

ROBERT W. FORSYTH. Two views of a
cradle with bas-relief carvings. Notice
also the decorative gouge work on the
corner posts and rails. This work was
executed in English oak.

E

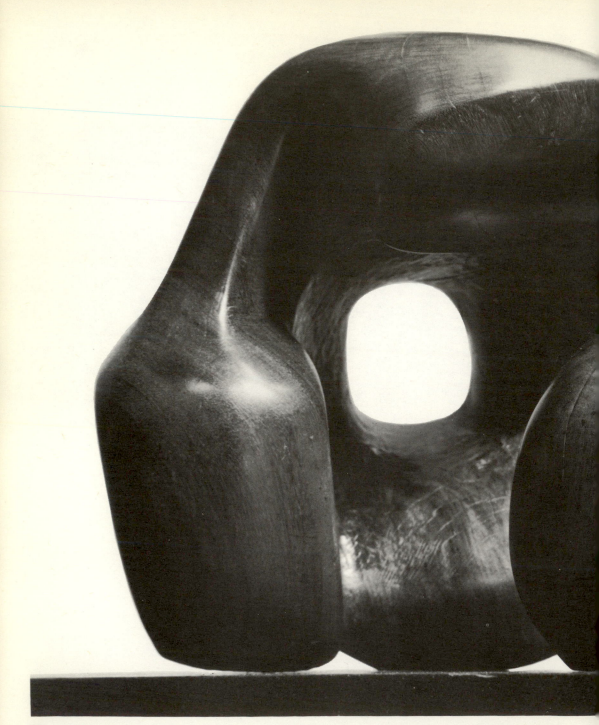

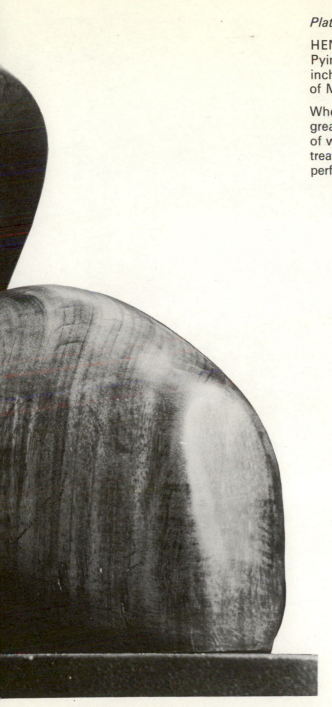

Plate 17

HENRY MOORE. Two forms, 1934 —
Pyinkado wood, oak base. Length 21
inches (533 mm). Collection — Museum
of Modern Art, New York.

Whenever possible, study the works of
great sculptors ; notice how the choice
of wood, grain direction, and surface
treatment all contribute towards the
perfection of the finished sculptures.

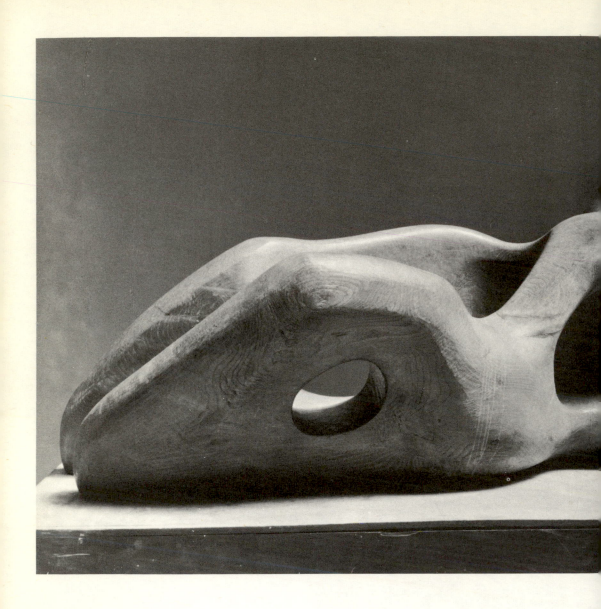

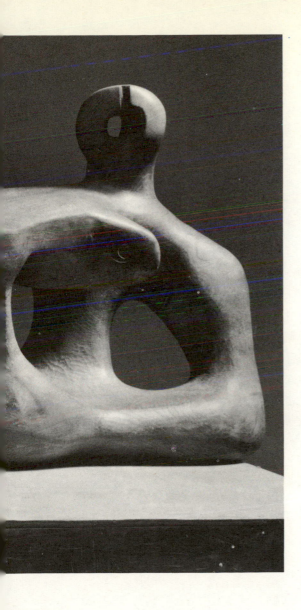

Plate 18

HENRY MOORE. Reclining Figure, 1939. Elm wood. Length 81 inches (2057 mm). Collection — Detroit Institute of Arts.

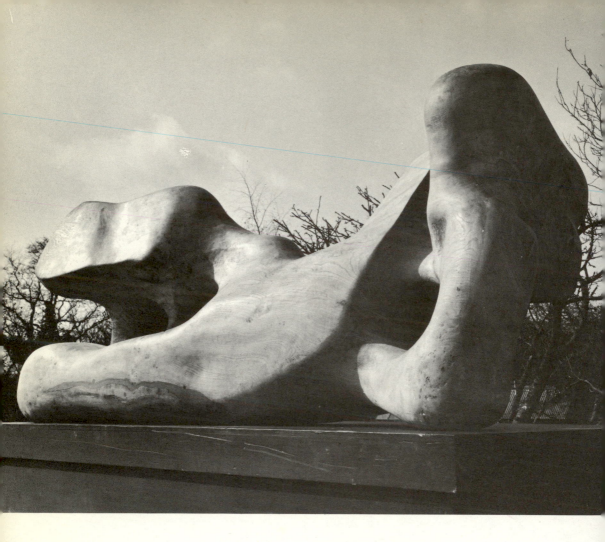

Plate 19
HENRY MOORE. Reclining Figure,
1959–64. Elm wood. Length 90 inches
(2286 mm). Collection – Henry Moore.

Plate 20
HENRY MOORE. Upright Figure (in
progress), carved in Elm. Height 108
inches (2743 mm). Collection –
Solomon R. Guggenheim Museum, New
York.

(photo : John Hedgecoe)

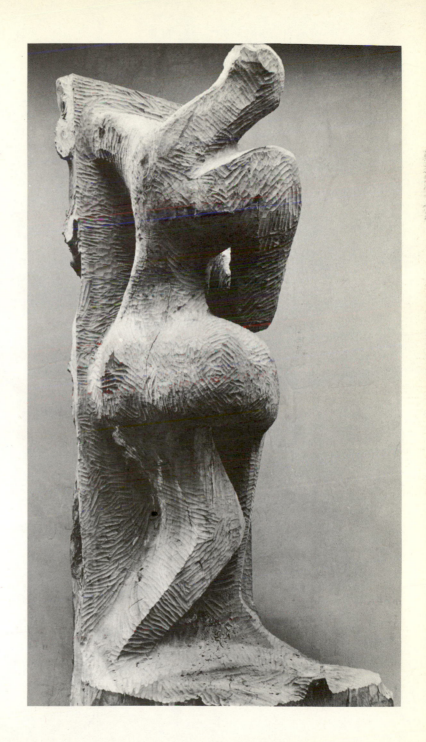

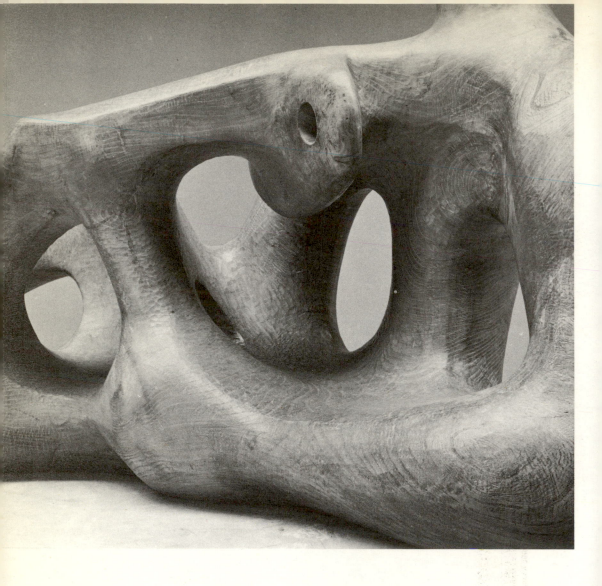

Plate 21 (*Detail from sculpture in Plate 18*).

HENRY MOORE. Reclining Figure, 1939. Elm wood. Length 81 inches (2057 mm). Collection — Detroit Institute of Arts.

(photo: Errol Jackson)

Plate 22

HENRY MOORE. Figure, 1930 — carved in ebony. Height 10 inches (254 mm). Collection — Mrs Michael Ventris, London.

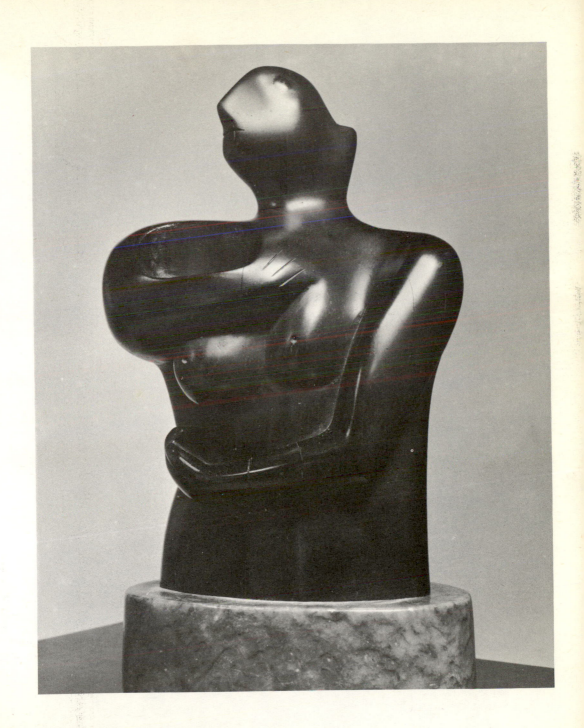

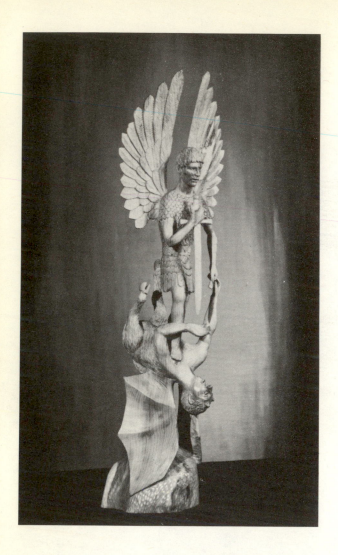

Plate 23

ROBERT W. FORSYTH. St. Michael and the Devil. English yew. Height 36 inches (914 mm). This is a model of a proposed statuary for a Church of St. Michael in Italy. To be carved from laminated oak, weight 5 tons, and standing 15 feet high.

Plate 24

Workmen raising a 2½ ton elm log with first rough cuts and shape of a standing constable — 14 feet high.

Finished figure in possession of the Home Office, Bramshill House, Senior Police Officers' College.

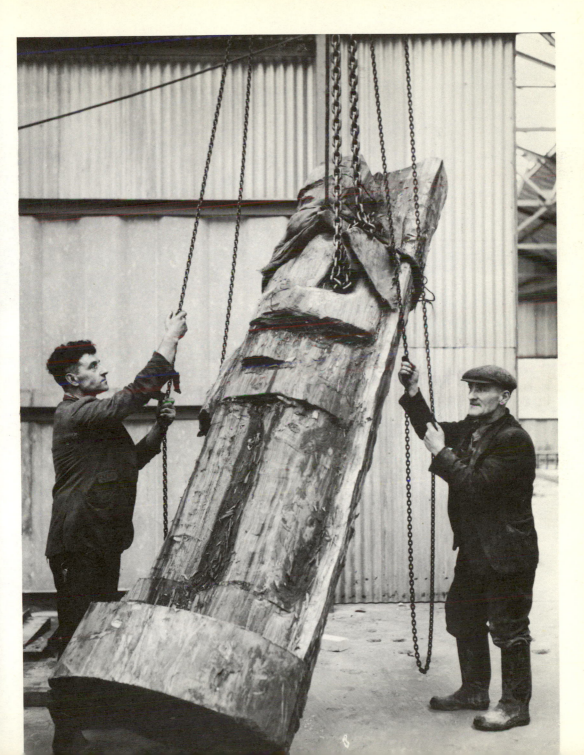

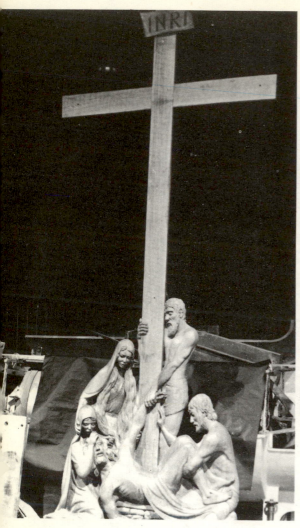

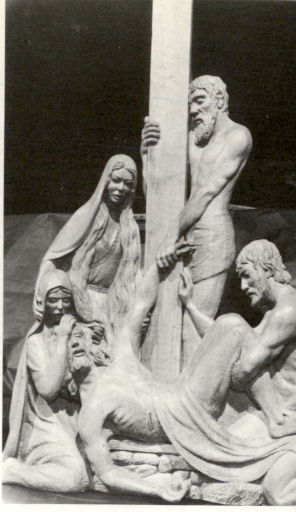

Plate 25

A life size pietà, carved in oak by Robert W. Forsyth. Installed in the Church of Our Lady of Pity, Buckland Dover.

Plate 26

A closer view of the pietà.

This group of figures has been designed and executed beautifully, and well within the limitations of the material. An example of fine technique. Note how the pose of the figures creates an immense depth of feeling in the group as a whole.

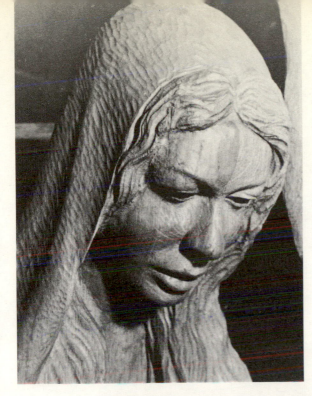

Plate 27

Detail of one of the figures. Take particular notice of the direction of the gouge-cuts and how it portrays the drapery — compare this technique with that used to fashion the garments of the Madonna, Plate 6.

Plate 28

Detail of the hand — see bottom of Plate 26.

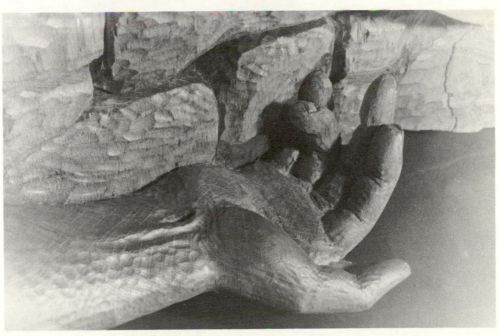

Plate 29

Architectural Carving. The Tibetan House,
The Pestalozzi Children's Village,
Sedlescombe, Sussex.

A fine example of incised lettering, in the
same style as that used for the inscription
on the base of the Emperor Trajan's
Column in Rome, A.D. 114.

The eminent American letterer and type
designer F. W. Goudy, in reference to the
Trajan lettering, once said: 'The shapes
and proportions are those of pen or
brush drawn letters, but the character is
that of the cutting tool used to produce
them.'

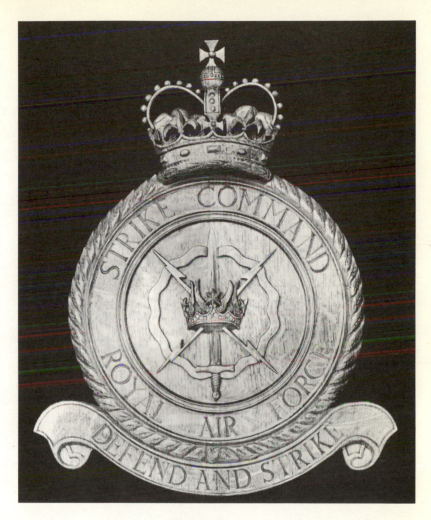

Plate 30

ROYAL AIR FORCE Strike Command
Crest. Carved in English oak. Height 24
inches (609 mm). Reproduced by
courtesy of G. Smirthwaite Esq.

Shadow lines created by relief carving
play an important part in this kind of
work; and by the same token the
incised lettering requires a correct depth
and angle of cut in order that it may be
read well from a distance.

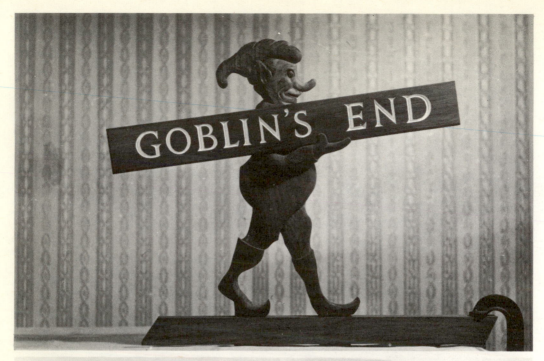

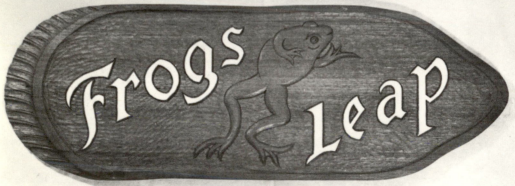

Plates 31 and 32

HOUSE NAME BOARDS

GOBLIN'S END has been incised in the Classical Roman (Trajan) style.

FROGS LEAP has letters with an 'Old English' flavour on a board with a carved ground. (Courtesy W. J. D. Clarke).

Plates 33 and 34

HOUSE NAME BOARDS

VALBRUNA is an example of raised lettering. The semicircular board has a raised border the same height as the letters. Notice the well-tooled 'ground'.

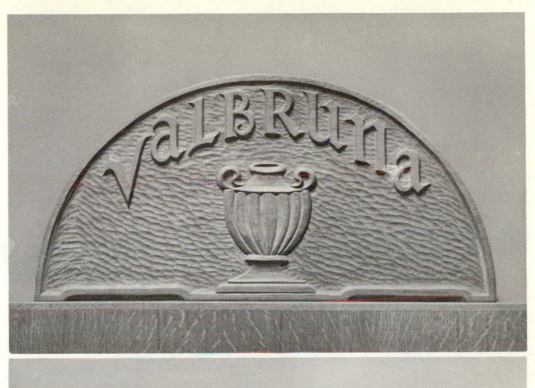

Plate 35
JUDY MITCHELL. Abstract, carved in hawthorn. Height 8 inches (203 mm).

Many abstract shapes can be formed from parts of trees that contain interesting grain structure, and in some cases, growth defects where the shaping or removal of the material is a direct exploitation of this. In such work, no attempt is made to represent any particular object.

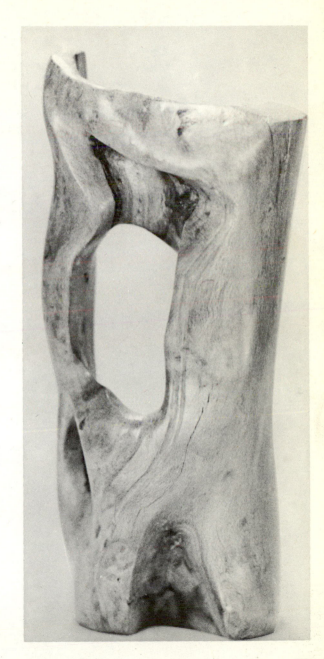

Plate 36

The sculpture in the previous plate;
seen from the other side.

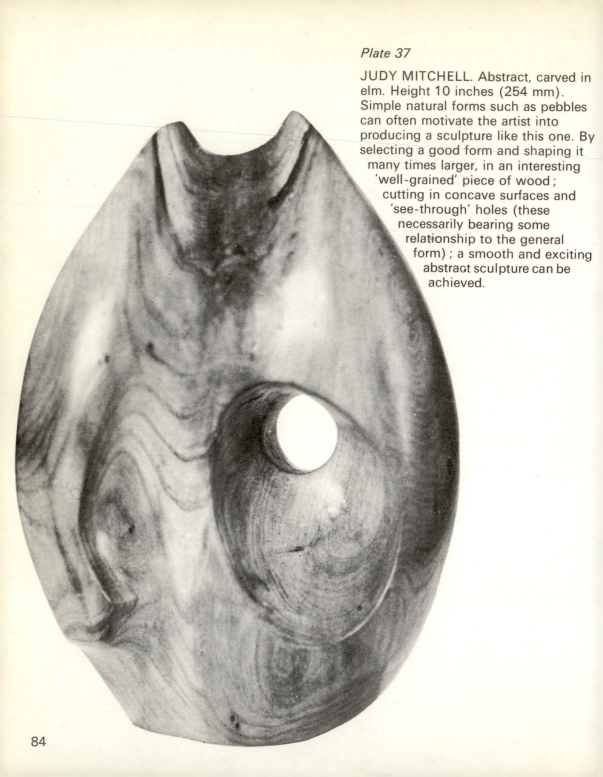

Plate 37

JUDY MITCHELL. Abstract, carved in elm. Height 10 inches (254 mm). Simple natural forms such as pebbles can often motivate the artist into producing a sculpture like this one. By selecting a good form and shaping it many times larger, in an interesting 'well-grained' piece of wood; cutting in concave surfaces and 'see-through' holes (these necessarily bearing some relationship to the general form); a smooth and exciting abstract sculpture can be achieved.

Plate 38

The sculpture in the previous plate;
seen from the other side.

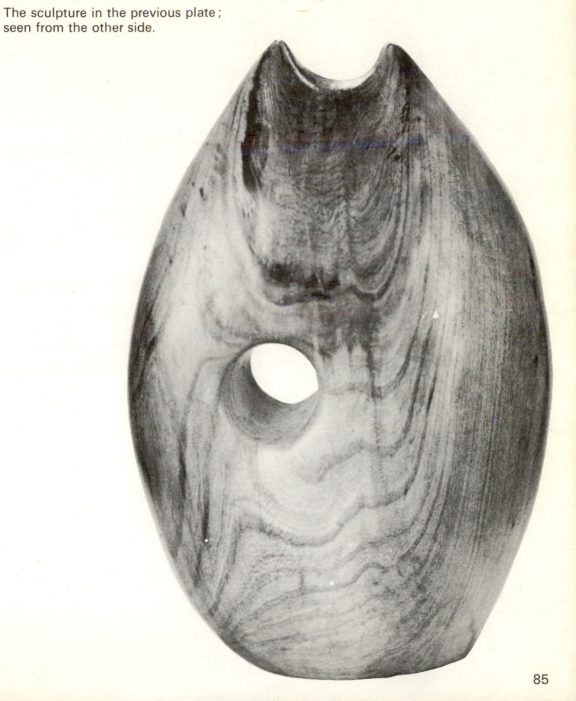

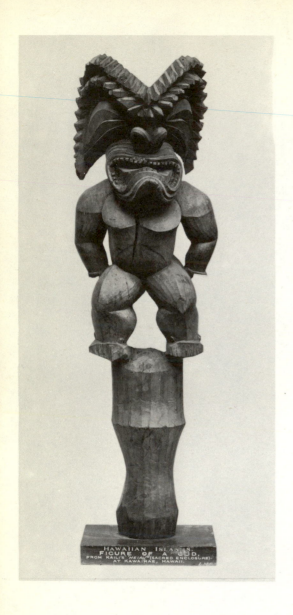

Plate 39

Wood figure of the war god, Ku, from a Marae (sacred place), Hawaii. Height 48 inches (1219 mm). British Museum.

Plate 40

Painted wooden mask from the North West Coast of America. Height 10.5 inches (265 mm). British Museum.

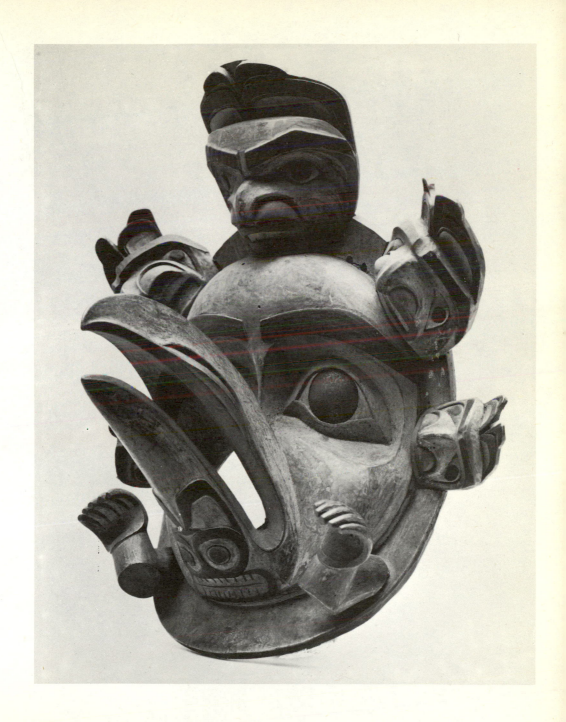

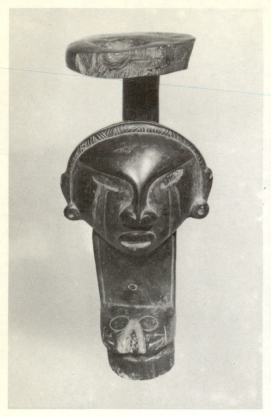

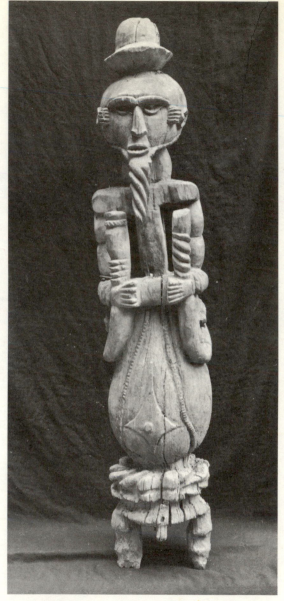

Plate 41 (*far left*)

Wooden carving from Jamaica. Possibly used as a snuff tray. Height 14.75 inches (375 mm). British Museum.

Plate 42 (*near left*)

Wood carving of ORON IBIBIO. Height 42 inches (1066 mm). Nigerian Museum, Lagos.

The name Ibibio is possibly derived from Ibis, a sacred bird found in Africa; and Ibo, a powerful Nigerian tribe.

Plate 43

Fetish figure of Spirit of Ancestor. From the Baluba tribe of the Congo, Equatorial Africa. Height 18.5 inches (470 mm). British Museum. In African sculpture what may at first glance appear to be inept is most often intended distortion. Limbs and other members are exaggerated in order to explain the function of a figure. The sculpture on the right has arms and legs that are quite short in relation to the torso, but their curves follow convincingly the natural lines of the human body.

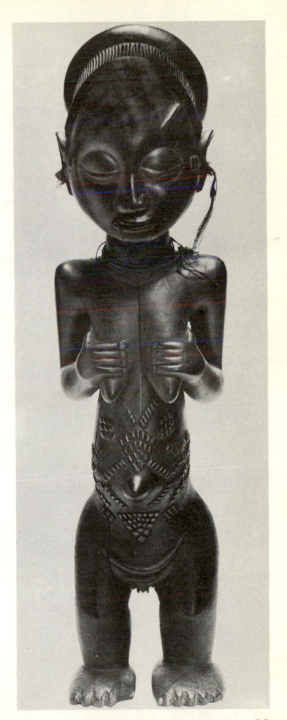

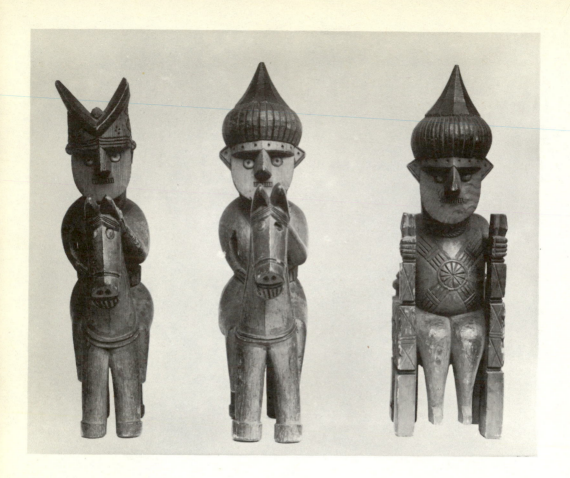

Plate 44

Grave figures; these are native models of larger ones that are placed on top of the graves. Kafiristan. Average height 8.5 inches (216 mm). British Museum.

Plate 45

Ancestor figure. Philippine Islands. Height 21 inches (533 mm). British Museum. Note how the arms and head reveal the studied simplification by the craftsman. This kind of native sculpture proved to be a source of inspiration to Picasso at the beginning of this century, just prior to his experimentation with cubism.

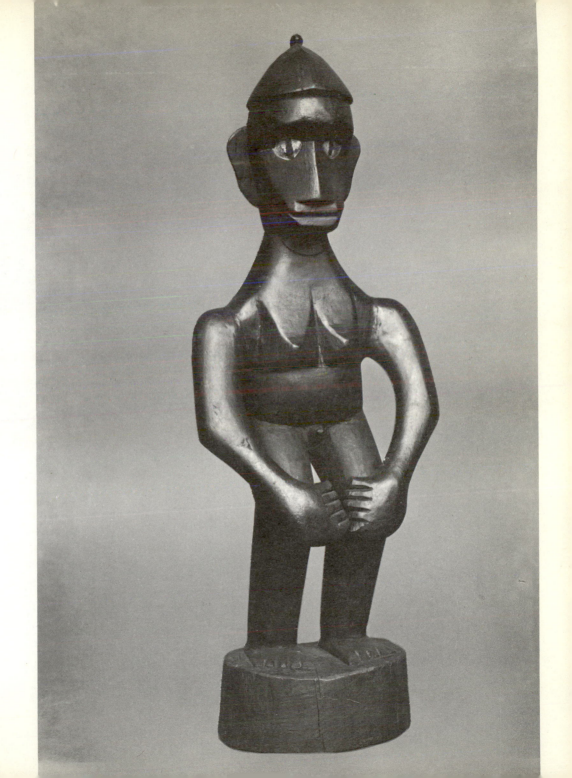

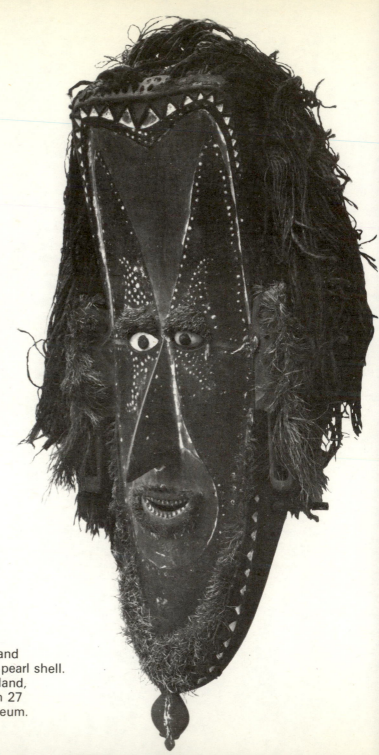

Plate 46

Wood mask with human hair and
vegetable fibre: eyes of inlaid pearl shell.
Used in fertility rites. Saibai Island,
Torres Straits, Oceania. Length 27
inches (685 mm). British Museum.

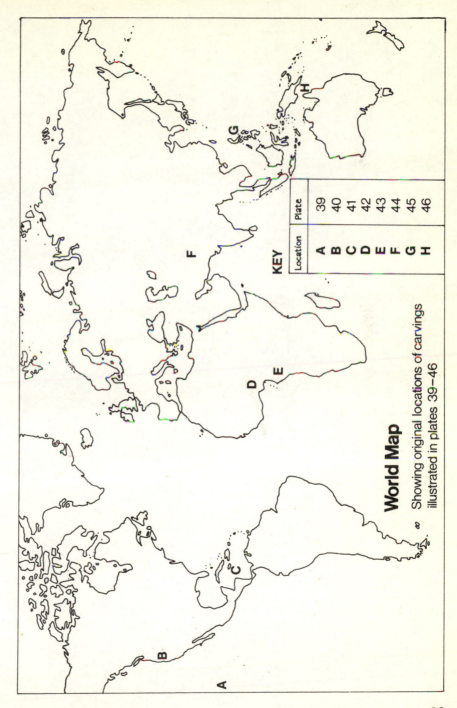

World Map

∞ Showing original locations of carvings illustrated in plates 39–46

KEY	
Location	Plate
A	39
B	40
C	41
D	42
E	43
F	44
G	45
H	46

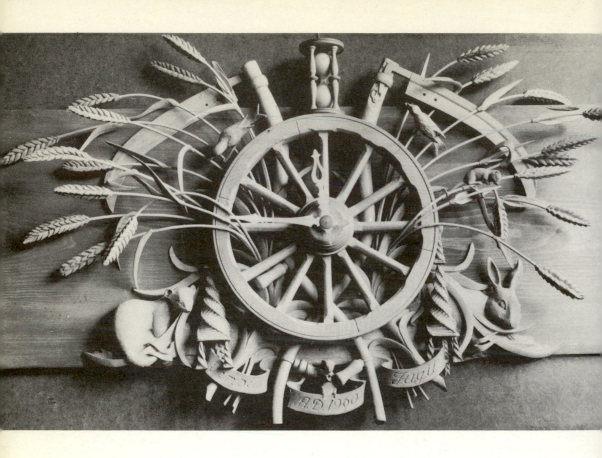

Plate 47

NANCY CATFORD. Board room clock, (Spillers Limited) carved in limewood. Length 34 inches (863 mm). Take particular note of the intricate carving of the small animals and birds. Notice also the incised inscription at the bottom. (Designed by J. Rodney Stone).

Plate 48

NANCY CATFORD. Bearded Tit, carved in yew and limewood. Height 13 inches (330 mm). A project like this presents carving problems that do not arise in the larger and more solid type of sculpture : the bird, twigs, and leaves all being carved separately and then fixed together before mounting onto the base.

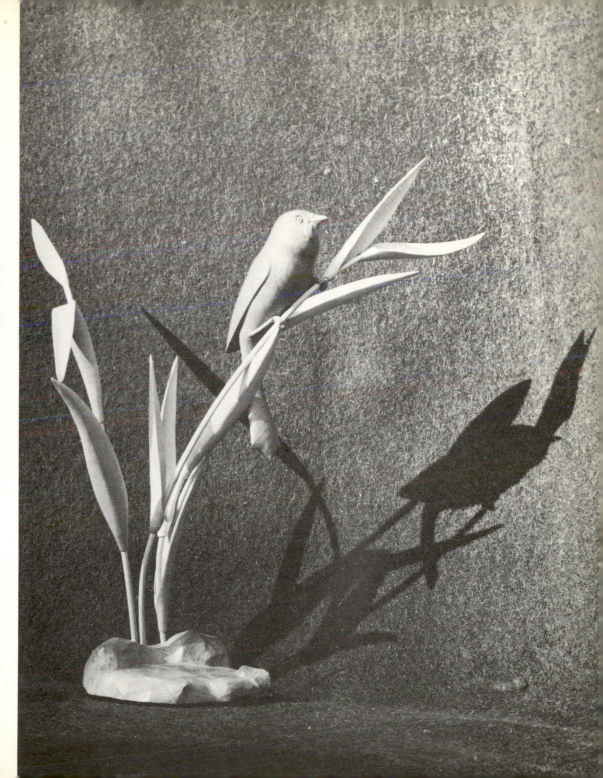

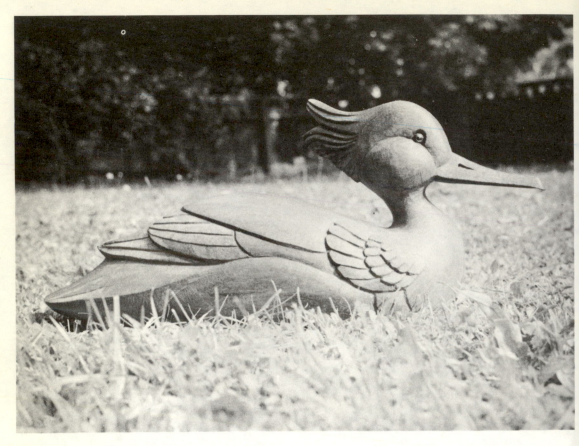

Plate 49

NANCY CATFORD. Merganser, carved in mahogany. Height 10 inches (254 mm).

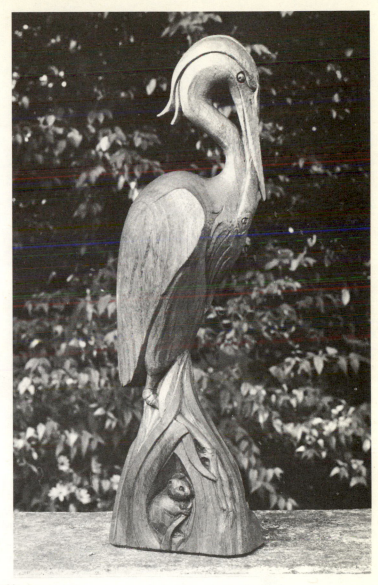

Plate 50

NANCY CATFORD. Fishing Heron,
carved in mahogany. Height 16 inches
(406 mm). An excellent balance has
been achieved between the sculpture
and the base. Notice also, how the
mouse has been 'niched' into the base,
adding interest to it.

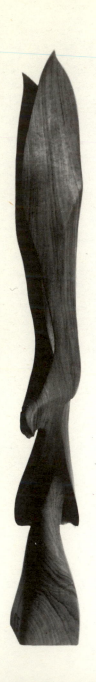

Plate 51

MICHAEL SMITH. 'The Descent'. A
wonderful exploitation of grain and form;
with the integration of base and subject
executed to perfection.

Plate 52

NANCY CATFORD. Tawny Owl, pine.
Notice how the ruggedness of the base
is accentuated by the 'wild' grain;
contrasts against the smooth, well-
rounded form of the subject.

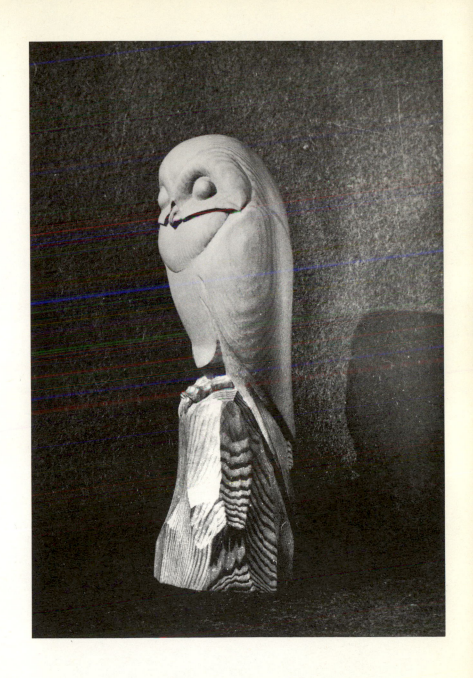

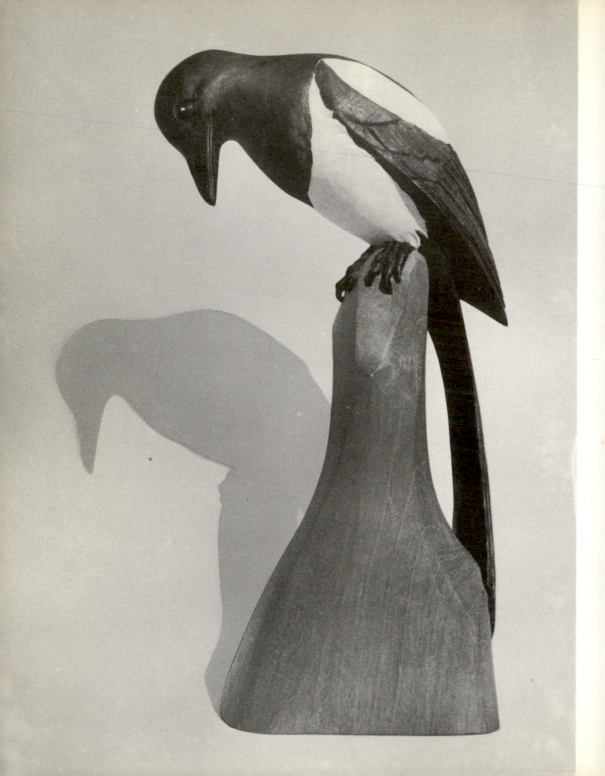

Plate 53

NANCY CATFORD. Magpie, painted mahogany. Height 14 inches (355 mm). The painting of this piece of sculpture was carried out for two reasons, first to protect the wood from climatic changes, and secondly, to give the magpie its true colouring.

Sculptures, like ordinary household items, require good surface preparation before painting begins. For good results the following points should be observed:

1 Paint does not stick well to sharp corners. These should be slightly rounded.
2 Open-grained woods should be 'filled' with Alabastine or plaster of Paris.
3 Use a thin undercoat. If more than one coat is applied, rub down between coats with a fine glasspaper.
4 Finishing coat. Use the smallest amount of paint necessary to obtain a good finish.

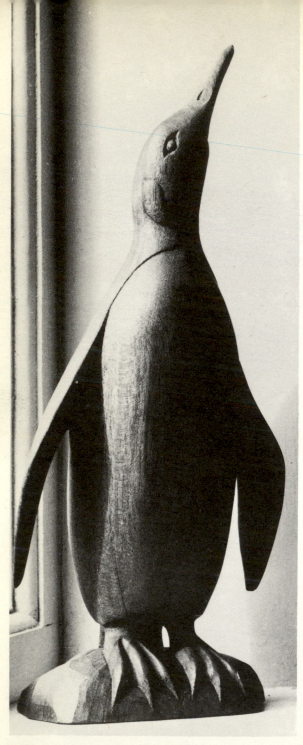

Plate 54

NANCY CATFORD. Penguin, mahogany. Height 11 inches (279 mm). One can see that in order to make the wings stand out from the body, the removal of quite a lot of wood was necessary. This form could well have been simplified to good effect.

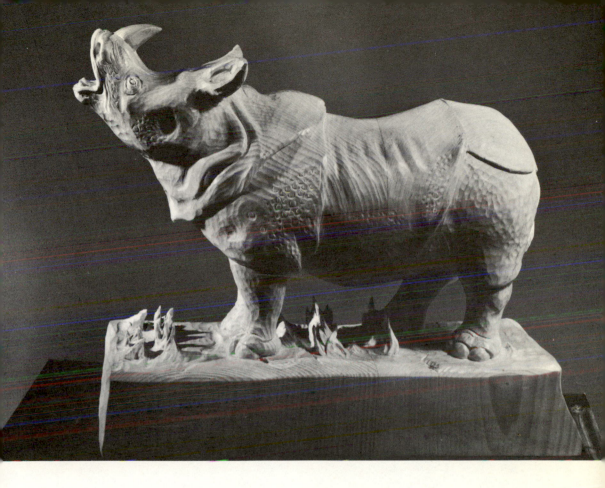

Plate 55

GINO MASERO. Rhino, Quebec pine. Height 20 inches (508 mm). A vigorous piece of carving, with a rich, well-'tooled' surface treatment, portraying in full the thick layers of folded skin, and also the massive weight of this animal.

Notice the vertical jointing of the wood; this can be followed through to the base, and one can see at a glance how well this has been 'matched'. The process of jointing wood (which must be done with extreme care) only becomes necessary when it is impossible to obtain wood of a sufficient size for a particular sculpture.

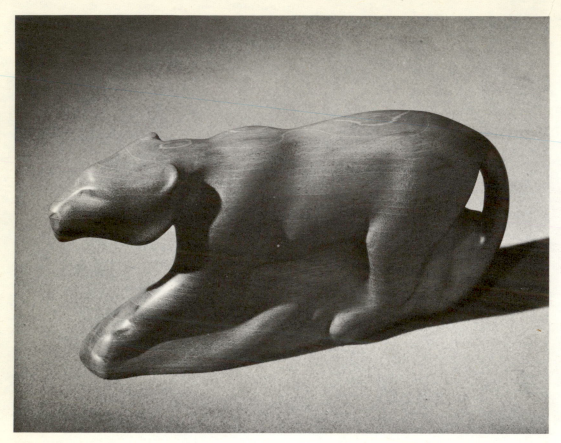

Plate 56

BARBARA LINLEY-ADAMS. Panther,
carved in mahogany. Height 12 inches
(304 mm). The aim here was to
concentrate on the main lines of the
animal, and to portray only the essential
details of the body structure. Notice how
the base of the sculpture is well
integrated into the general form.

Plate 57

NANCY CATFORD. Bear, carved in French walnut. Length 8 inches (203 mm). Notice the direct tool marks on the surface. Also how the excellent positioning of the main forms helps to show the large, heavy quality of the bear, and how a certain feeling of movement has been created.

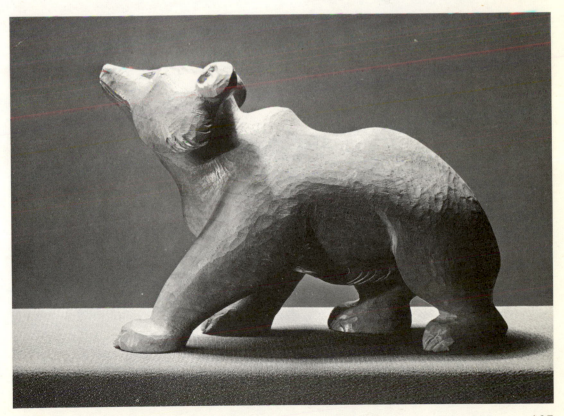

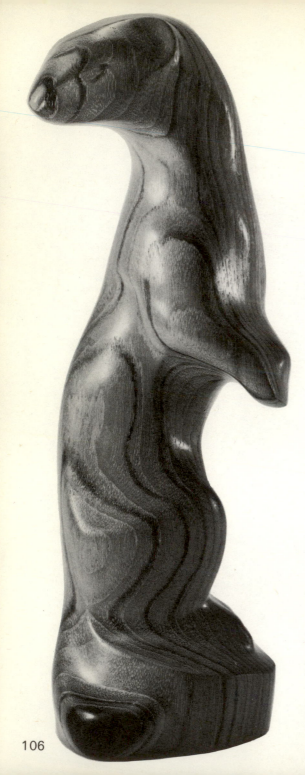

Plate 58

BARBARA LINLEY-ADAMS. Stoat, carved in teak. Height 10 inches (254 mm). Exhibited at the Royal Academy in 1965.

Notice how the form has been simplified and the surface finished to a very high degree. Note also the delightful effect of the grain which tends to accentuate the rhythm and movement of this form.

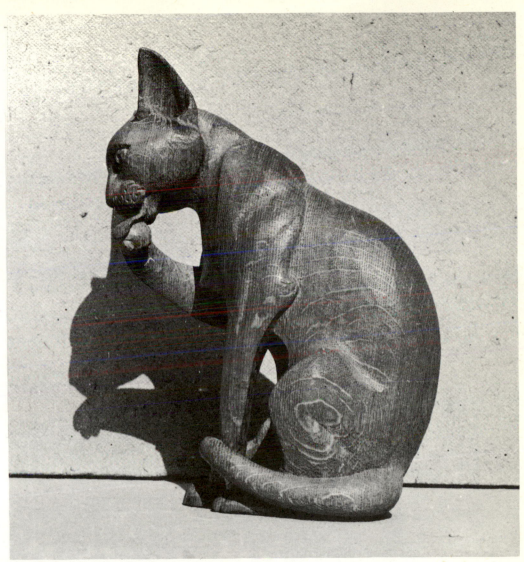

Plate 59

NANCY CATFORD. Washing cat, carved in oak. Height 10 inches (254 mm). If you intend to carve animals, choose a solid type, or design it lying down (see frontispiece, also plate 60). A cat curled up, or sitting (like this one) proves to be a good subject.

Plate 60

BARBARA LINLEY-ADAMS. Gazelle, carved in yew. Length 10 inches (254 mm). Exhibited at the Royal Academy in 1961.

When setting out on a project, regardless of what kind of form may be in mind, the task can be approached in two ways. First we may pick out a block of wood simply because it bears in its shape and structure some resemblance to the form that we may have conjured up in our imagination; on the other hand we can cut out our required shape or form from almost any block of suitable size.

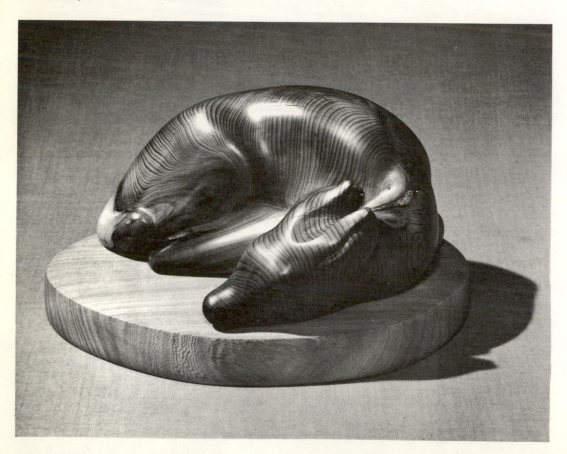

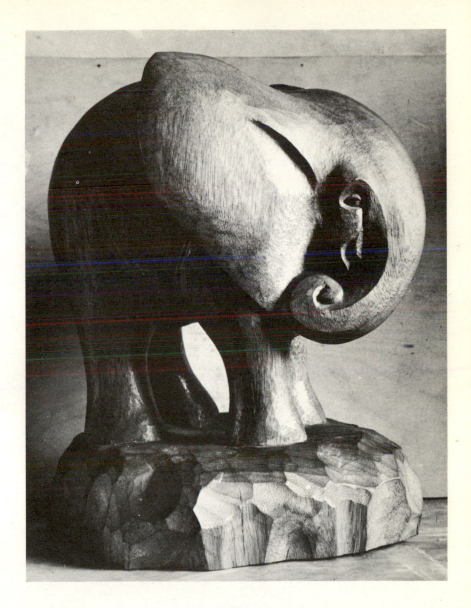

Plate 61

NANCY CATFORD. Young Elephant,
carved in mahogany. Size 11 × 8 × 7
inches (279 × 203 × 177 mm). Notice
how the base has been left well 'tooled'
by way of contrast to the main form.

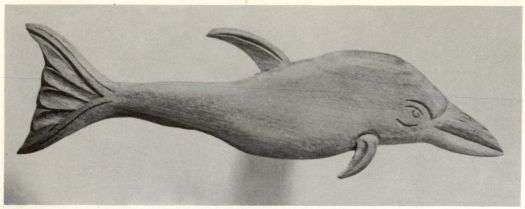

Plate 62

Gilded Dolphin. Oak. Ornamentation for
the yacht Pacific Moon. (Courtesy
W. J. D. Clarke).

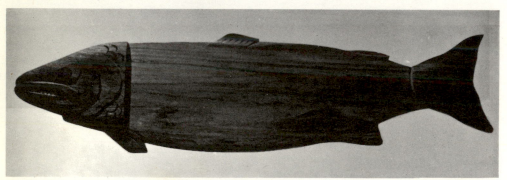

Plate 63

Fish Platter. Teak. (Courtesy W. J. D.
Clarke).

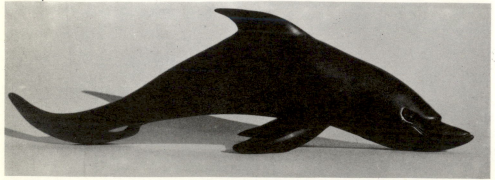

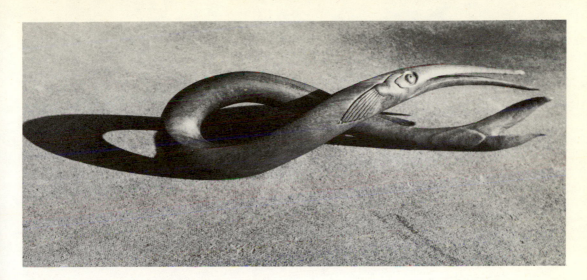

Plate 65

NANCY CATFORD. Garfish, carved in mahogany. Length 11 inches (279 mm). A deliberate attempt was made to capture the feeling of this creature in wood, thus taking the limitations of the material to the extreme.

Plate 64
Porpoise. Ebony. This was carved as a mascot for one of Her Majesty's Submarines. By Nancy Catford.

Sculpture by Children

'It would be part of my scheme of physical education that every youth in the state — from the King's son downwards — should learn to do something finely and thoroughly with his hand, so as to let him know what touch meant; and what stout craftsmanship meant; and to inform him of many things besides which no man can learn but by severely accurate discipline in doing.'

John Ruskin

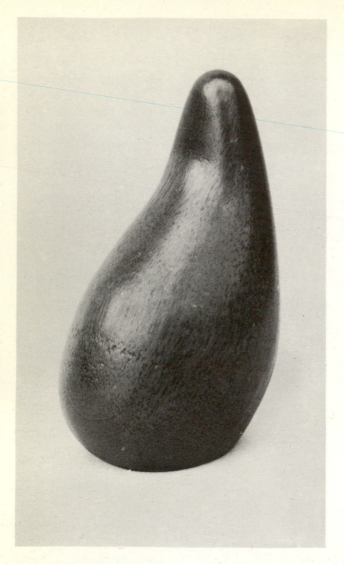

In every child there is an instinctive urge to fashion shapes of one kind or another, and in most, an aptitude for spontaneous creation and inventiveness. Illustrated in this section are a few examples of work by children from eleven to thirteen years old.

The basic tools used to produce these excellent little sculptures were, Surform shapers and wood rasps, with glasspaper to give the final smooth finish.

Plate 66
Here a considerable harmony has been
achieved between the simple shape of
the figure and the grain of the wood.

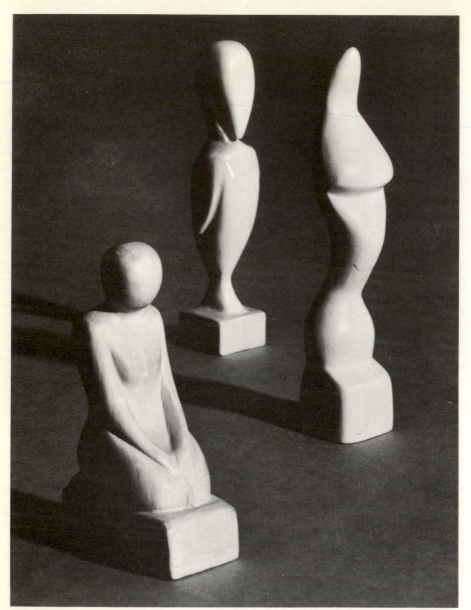

Plate 67
The important thing here was to
concentrate on the main lines of the
figures and not get lost in any fussy
details.

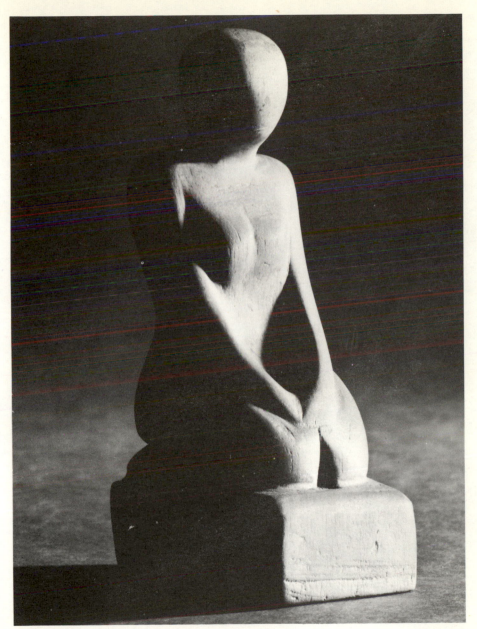

Plate 68
Notice how well the play of light and
shadow helps to portray this simplified
little figure.

Plate 69
This pleasing little sculpture has a
flawless surface and a nice even
curvature without any unnecessary
undulations. Notice the good balance
between base and sculpture.

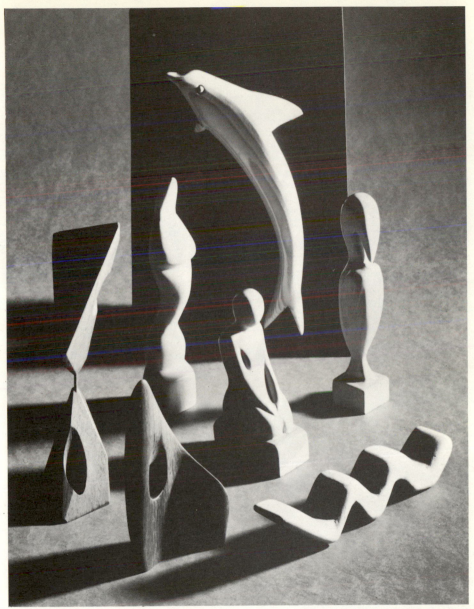

Plate 70
The position of light and shade plays an
important part in all types of sculptural
work. Notice and compare the effect it
has on each one of the sculptures in
this group.

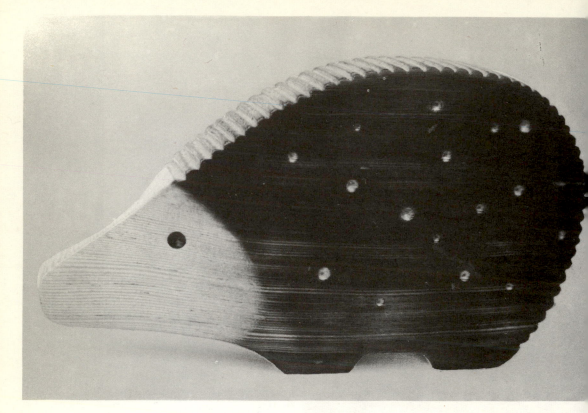

Plate 71

The darkened sides of the hedgehog were achieved simply by scorching with a blow-lamp. The shallow holes were then drilled in to simulate the spines.

Safety Precautions

1 Always remember that no part of either of your hands should be at any time in front (chisels and gouges can't cut backwards) of the cutting edge of a tool. This applies also to the screwdriver.

2 The sharpness of a gouge or chisel is NOT tested by rubbing your finger or thumb along the cutting edge.

3 Keep edged tools and heavy items well away from the edge of the bench where they may be easily knocked off, causing cuts or bruises to the legs or feet.

4 NEVER try to catch a falling tool.

5 Don't have your polishing mediums near a naked flame.

6 Have a first-aid kit to hand – just in case.

Conclusion

The very fact that you are reading this conclusion proves beyond all doubt that you are interested in Wood Sculpture and in finding out how to set about creating works of art yourself. It is for you therefore, and many others like you, that this book has been produced; in the hope that in its contents you may find inspiration. And, when you are inspired and your creative faculty is awakened — then go ahead and carve. Many mistakes will be made by the novice, but always bear in mind, that only through seemingly endless mistakes and failures, can ability and success be achieved.

Bibliography

Sculpture in Wood, P. Edward Norman (Alec Tiranti, London; Transatlantic, New York).

Whittling and Woodcarving, E. J. Tangerman (Dover Publications, Inc.).

Design and Figure Carving, E. J. Tangerman (Dover Publications, Inc.).

Creative Wood Craft, Ernst Rottger (Batsford, London; Van Nostrand, New York).

Woodcarving, Design and Workmanship, G. Jack (Pitman).

What Wood is that? A. Schwankl (Thames and Hudson, London; Viking Press, New York).

Timber for Woodwork, J. C. S. Brough (Evans, London).

Modern Sculpture, Alan Bowness (Studio Vista Ltd, London; Dutton, New York).

Timbers of the World, A. L. Howard (Macmillan).

Engraving on Wood, John Farleigh (Dryad).

Indian Sculpture, Philip Rawson (Studio Vista Ltd, London; Dutton, New York).

African Sculpture, William Fagg and Margaret Plass (Studio Vista Ltd., London; Dutton, New York).

Greek Sculpture, John Barron (Studio Vista Ltd, London; Dutton, New York).

New Materials in Sculpture, H. M. Percy (Studio Vista Ltd, Transatlantic, New York).

Figures in Wood of West Africa, L. Underwood (Transatlantic, New York).

Minor English Woodcarving, A. Gardner (Transatlantic, New York).

African Sculpture, Ladislas Segy (Dover Publications, Inc.).

Design for Artists and Craftsmen, Louis Wolchonok (Dover Publications, Inc.).

A Dictionary of Wood, E. H. B. Boulton (Nelson).

For General Reading

A Dictionary of Modern Sculpture, edited by Robert Maillard (Methuen and Co Ltd).

A Concise History of Modern Sculpture, Herbert Read (Thames and Hudson Ltd., London; Praeger, New York).

Sculpture: Theme and Variations, E. H. Ramsden (Lund Humphries and Co Ltd).

The Art of Sculpture, Herbert Read (Faber and Faber Ltd., London; Princeton U. Press, Princeton, N. J.).

Relative value of inches and millimetres

Carving tools are obtainable in both English and Metric sizes, and for the purpose of serving as a guide to those about to embark on building up a set of tools. I have included the tables below.

mm	Inches	Inches	mm
1	0·0394	1/16	1·587
2	0·0787	3/32	2·381
3	0·1181	1/8	3·175
4	0·1575	5/32	3·967
5	0·1968	3/16	4·762
6	0·2362	7/32	5·556
7	0·2756	1/4	6·350
8	0·3150	9/32	7·144
9	0·3543	5/16	7·937
10	0·3973	11/32	8·731
11	0·4331	3/8	9·525
12	0·4724	13/32	10·319
13	0·5118	7/16	11·112
14	0·5512	15/32	11·906
15	0·5906	1/2	12·700
16	0·6299	17/32	13·494
17	0·6693	9/16	14·287
18	0·7087	19/32	15·081
19	0·7480	5/8	15·875
20	0·7874	21/32	16·668
21	0·8268	11/16	17·462
22	0·8661	23/32	18·256
23	0·9055	3/4	19·050
24	0·9449	25/32	19·844
25	0·9843	13/16	20·637
26	1·0236	27/32	21·431
27	1·0630	7/8	22·225
28	1·1024	29/32	23·018
29	1·1417	15/16	23·812
30	1·1811	31/32	24·606
31	1·2205	1	25·400